Ettore Camesasca

MANTEGNA

SCALA

Index of the illustrations

Other artists

© Copyright 1992 by SCALA group S.p.A.
Antella (Florence)
Translation: Susan Madocks Lister
Editing: Karin Stephan
Layout: Fried Rosenstock
Photographs: SCALA (M. Falsini and M. Sarri) except
nos. 2-10, 17 (Archivio Alinari, Florence); nos 21, 22
(Metropolitan Museum of Art, New York); nos. 35-37,
102-106 (National Gallery, London); nos. 39, 40
(Gemäldegalerie, Berlin-Dahlem); no. 50
(Kunsthistorisches Museum, Vienna); no. 53 (Museo Poldi
Pezzoli, Milan); no. 74 (National Gallery of Art,
Washington); no. 76 (Statens Museum, Copenhagen);
nos. 79-88 (reproduced by gracious permission of Her
Majesty the Queen); no. 91 (Gemäldegalerie, Dresden);
no. 92 (Petit Palais, Paris)
Printed in Italy by Amilcare Pizzi s.p.a. - arti grafiche
Cinisello Balsamo (Milan), 2000

1. Self-portrait in bronze
Mantua, Sant'Andrea (Mantegna's funerary chapel)

The Early Years

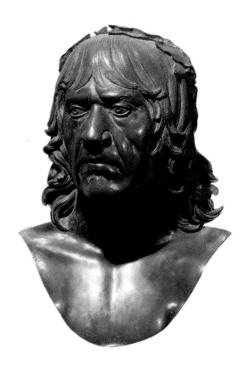

Andrea Mantegna was born in 1430 or 1431 probably at Isola di Carturo (now named after the artist) near Piazzola between Vicenza and Padua. His date of birth has been deduced from an inscription on a lost painting of 1448 in which he declared himself to be seventeen years old.

The son of a carpenter, Mantegna was about ten years old when he was adopted, some time before 1442, by Francesco Squarcione who started him off on his artistic career and with whom Andrea had a stormy falling out in 1448. This adoptive father emerges as an ambiguous figure in the accounts of the early historians: a difficult man who transformed himself from a tailor and embroiderer into a painter and art teacher. This latter role came about because of his fine collection of antique statues and classical casts. Squarcione became something of a self-interested talent-scout whose numerous adopted sons sooner or later rebelled against his exploitation. His only known painting, an altarpiece dated 1449 in the civic museum of Padua, combines northern characteristics with hints of Tuscan influence. Despite its somewhat harsh elements, the vivid and original style of this painting is an accurate reflection of the state of the visual arts in Padua at that moment. After the long survival of the Gothic style into the fifteenth century the new Renaissance style was brought to the Padua and Venice area by the presence of Andrea del Castagno in 1422, of Paolo Uccello from 1423-31 and again in 1445 and Filippo Lippi in 1434. Of greater significance were the ten years of Donatello's permanence in Padua working on sculptural projects for the Basilica del Santo.

Niccolò Pizzolo was also drawn to the innovative Florentine style. Assistant to Lippi and later to Donatel-lo, Pizzolo worked with Mantegna on half of the fresco decoration of the Ovetari chapel in the Eremitani church in Padua. The other half was entrusted to Antonio Vivarini and Giovanni d'Alemagna. The fresco cycle was almost totally destroyed by the aerial bombing of 1944 and consequently, despite the pre-war photographic records, problems of chronology and attribution are enormously complicated.

Mantegna's involvement in the chapel begins with three figures of saints — Peter, Paul and Christopher — painted in the segments of the vault of the apse. By 1450 he had frescoed the *Calling of Saints James and John* and the *Preaching of St James* in the lunette at the top of the left hand wall which had been reserved for him. The style is similar to that of Pizzolo with the same handling of space according to the Brunelleschian centralized perspective system although there is evidence of some technical uncertainty.

In the two frescoes below, *St James Baptizing Hermogenes* and *St James before Herod Agrippa* perspective has been fully mastered. The view-point, which is lower than in the scenes above where there is a central vanishing point, is situated on the painted frame which separates the two scenes, so as to unify the episodes. In addition, the figures are given a greater sense of the three dimensional through a sharp and emphatic modelling reminiscent of Castagno. Further innovations are revealed in the proliferation of details drawn from classical antiquity: pillars, medallions and simulated reliefs carved with figures or Latin inscriptions. In *St James before Herod Agrippa* a triumphal arch fills two thirds of the composition. These elements share the stage with the figures on an almost equal footing. Mantegna has been credited with the invention of these

classicizing additions but that is inaccurate since his future father-in-law Jacopo Bellini, father of the painters Gentile and Giovanni, had already completed one of his famous books of drawings where similar, and sometimes identical, arches, capitals, friezes and medallions appear in the *Ecce Homo*, the *Flagellation* and other scenes. So, Mantegna's use of antique elements can be seen, rather, as part of his artistic formation which was typical of the late Gothic period with that poetic propensity to see classical ruins as fragments of a past grandeur and as a kind of inspirational force.

At the end of 1451 work at the Eremitani church came to a halt because of lack of funds. It was taken up again in November of 1453 and possibly finished in January 1457. Datable to that period are the final episodes of the life of St James on the left hand wall, *St James led to Execution* and the *Martyrdom of St James*, together with the two corresponding frescoes on the opposite wall, the *Martyrdom of St Christopher* and the *Removal of the Body of St Christopher* and the *Assumption of the Virgin* in the apse of the chapel. The last three frescoes are all that remain. Because of their deteriorating condition they had been detached from the wall in 1880 and were therefore saved from the bombing of 1944. In addition, a few fragments of the *Martyrdom of St James* have been applied to an enlarged photograph of the original fresco.

The quality of the two episodes of St James is characterized by yet more innovations such as the expert and bold foreshortening of figures and architecture alike. Also, the background of the *Martyrdom* flickers with tiny figures and is dominated by a view of a city part medieval and part ideal. The precise yet delicate brushwork of the preceding works gives way to a denser, fuller more harshly shadowed laying on of the paint which imparts the feeling of rare and precious stones to the frescoes.

It should be noted that the *Martyrdom of St James* and the two St Christopher episodes were originally contracted to Pizzolo; Mantegna undertook their execution following the death of his associate in 1453. This could explain a certain discrepancy in the imaginative power of the *Martyrdom* compared to the scenes of *St James led to Execution* beside it. To make up for it, the two St Christopher episodes share not only the same perspective view-point but the same architectural setting as well; this is rendered with such illusory power that it comes close to being a kind of *trompe-l'oeil*. Old copies of the fresco reveal elements which overlap the painted frame of the fresco and appear to invade 'our' space, such as the young man to the far right.

As for the *Assumption of the Virgin*, Mantegna here unfolds those talents already displayed on the main walls of the chapel by opening up the central space of the fresco. He manages to give the impression that the Virgin is both ascending to heaven and at the same time communicating with the Apostles below. They in their turn enter our world through the device of one of them clinging to the painted arched frame thus inviting our participation in the event.

Further work by Mantegna at the Eremitani church includes a Colossal Head and the painted frame between the frescoes on the left hand wall. These yield a wealth of illusory devices which must have drawn together and emphasised the narrative power of the entire decorative scheme. All this provides further evi-

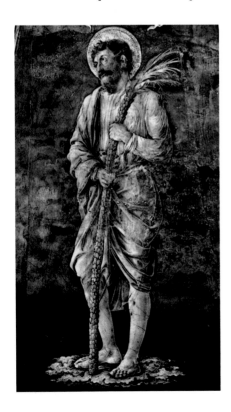 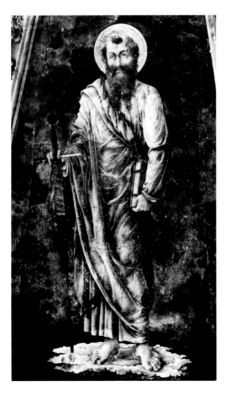 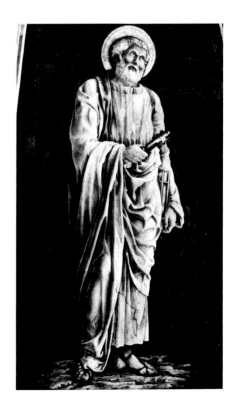

The frescoes of the Ovetari chapel in the Eremitani church in Padua, photographed before their destruction in 1944

2-4. Frescoes of the vault of the apse of the Ovetari chapel representing Saints Christopher, Paul and Peter

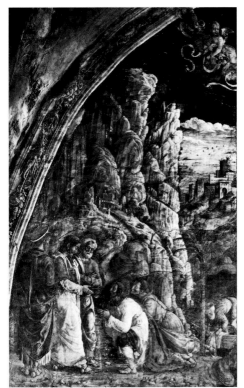

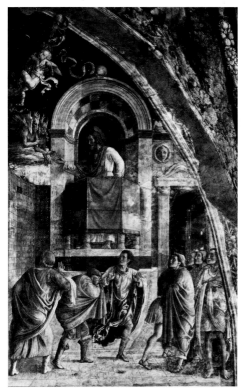

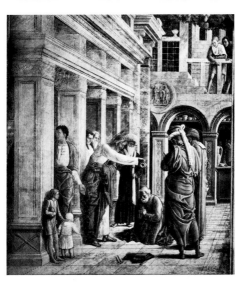

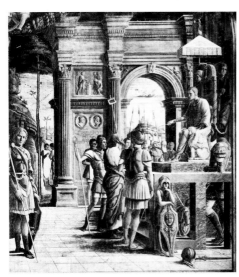

5-10. Scenes on the left hand wall of the Ovetari chapel showing, from left to right: The Calling of Saints James and John, the Preaching of St James, St James Baptizing Hermogenes, St James before Herod Agrippa, St James Led to Execution and the Martyrdom of St James

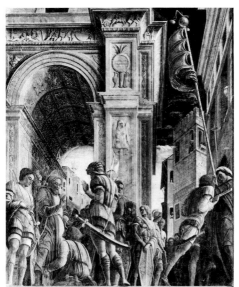

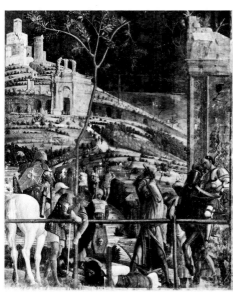

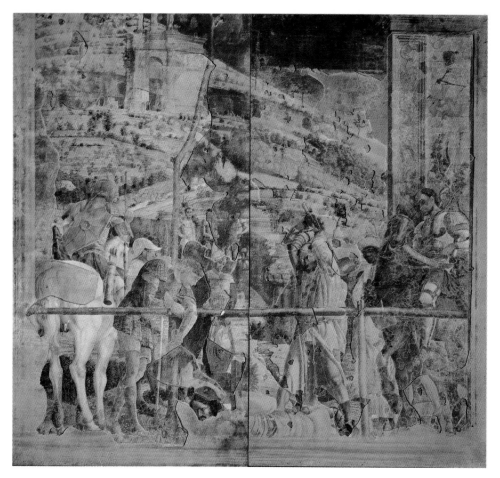

11. *The Martyrdom of St James in its present state of conservation*

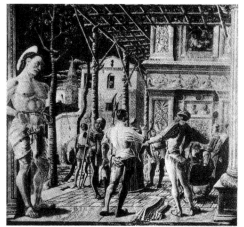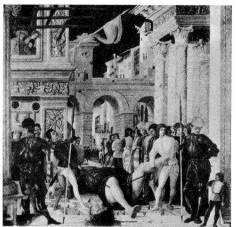

12, 13. *Martyrdom of St Christopher and Removal of his Body, in a copy of the original fresco now in the Musée Jacquemart-André in Paris*

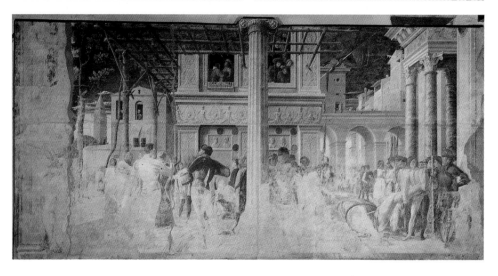

14-16. *Martyrdom of St Christopher and Removal of his Body, with details, in its present state of conservation*

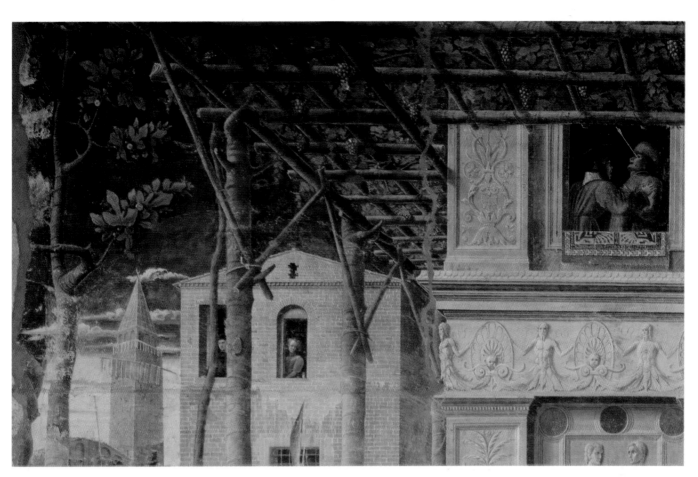

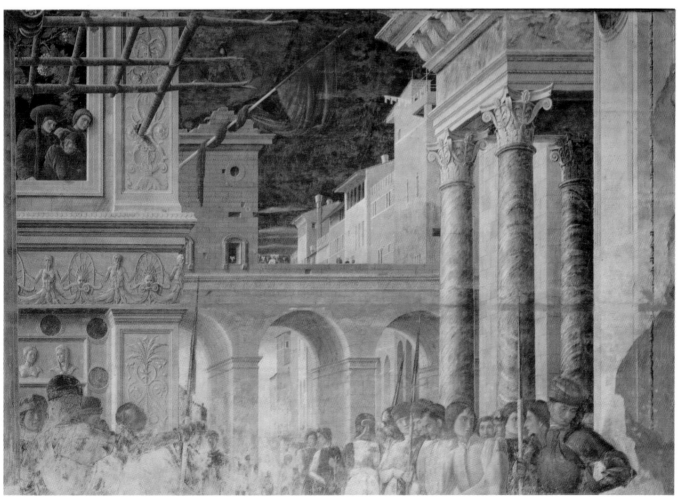

17. Colossal Head, formerly in the Ovetari chapel

19. Monogram of Christ between two Saints
base 316 cm
Padua, Museo Antoniano

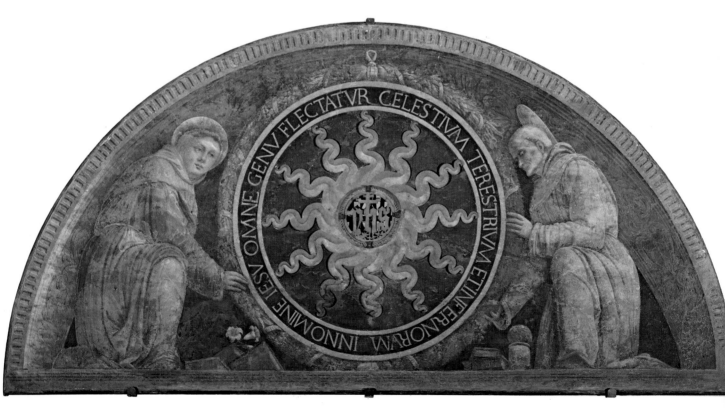

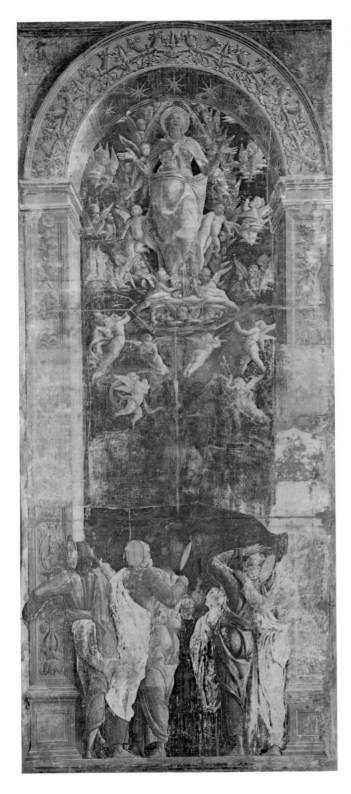

18, 20. Assumption of the Virgin and detail
base 238 cm
Padua, Ovetari chapel

21, 22. Adoration of the Shepherds and detail
40 x 55.5 cm
New York, Metropolitan Museum of Art

dence of Mantegna's progressive liberation from the late Gothic style which is replaced by Donatellian ideas such as the depiction of those far-off Christian stories with an immediacy suggestive of current events. Donatello's ideas on perspective are, however, interpreted rather more freely by Mantegna in his bold handling of space; in this he was probably following Pizzolo's example. Jacopo Bellini seems to be the main influence both on Mantegna's slender figure types and on the landscape backgrounds.

The complexities inherent in the Eremitani frescoes provide a framework for understanding other works of the period. For example, the irregular perspective of the lunette frescoes in the Ovetari chapel suggests a dating of 1450-51 for the *Adoration of the Shepherds* in New York (cut at the sides). This was probably commissioned by the court of Ferrara where, in 1449, the young Mantegna had done a portrait of the duke, now lost. There Mantegna came under the long-lasting influence of Piero della Francesca and of Flemish painters, particularly Rogier van der Weyden, whose work was well represented in Ferrara. Piero's influence is discernible in the distant landscape of the *Adoration* whereas the physiognomical exactness of the shepherds' faces reflect the impact of Flemish painting. The rough devotion of the shepherds contrasts with the rapture of the Virgin and it is the device of the proscenium which concentrates our attention on this expressive key-note of the painting — the different manifestations of religious feeling (K. Christiansen).

On 22 July 1452 Mantegna finished the fresco depicting the *Monogram of Christ between two Saints* above the main entrance of the Basilica del Santo (it is now in the Museo Antoniano). This work marks the beginning of Mantegna's use of the low vanishing-point of the perspective which he used shortly afterwards for the two final episodes of the story of St James. A dating of 1453-54 is certain for the Polyptych of St Luke painted for a Paduan church and now in the Brera, Milan. The altarpiece is divided following Gothic tradition into several panels and the size of its figures varies in accordance with the Byzantine hierarchy of saints. Despite these archaicisms one nevertheless gets the feeling of a loggia filled with statues which look out in various directions. Here and there a toe or a piece of drapery or even St Luke himself with half of his writing-desk, project into 'our' space. The date 1454 appears on the *Saint Euphemia* in Naples. She stands framed by an arch which has to be read as a window reflecting similar ideas in the Ovetari *Assumption of the Virgin* and the *St Mark* in Frankfurt (possibly workshop).

In 1453 or 1454 Mantegna married Nicolosia Bellini and in so doing allies himself professionally with her brother, Giovanni, to whom he imparts Donatellian ideas. The two London panels depicting the *Agony in the Garden* by Mantegna and Bellini respectively define

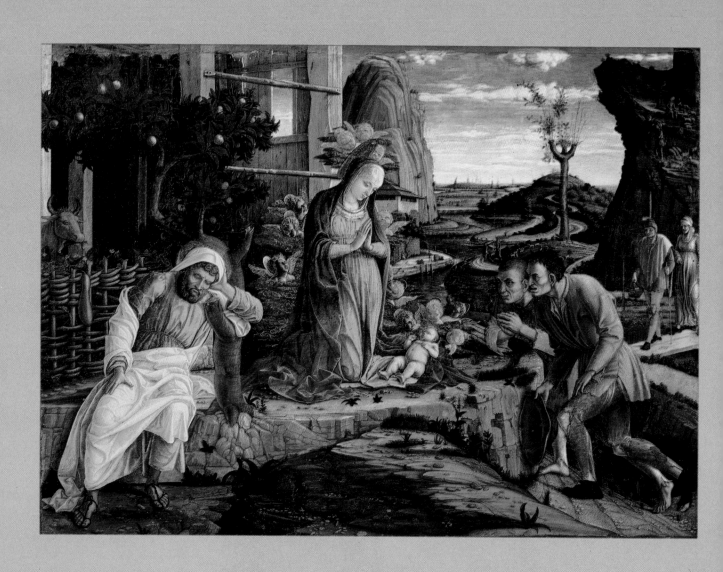

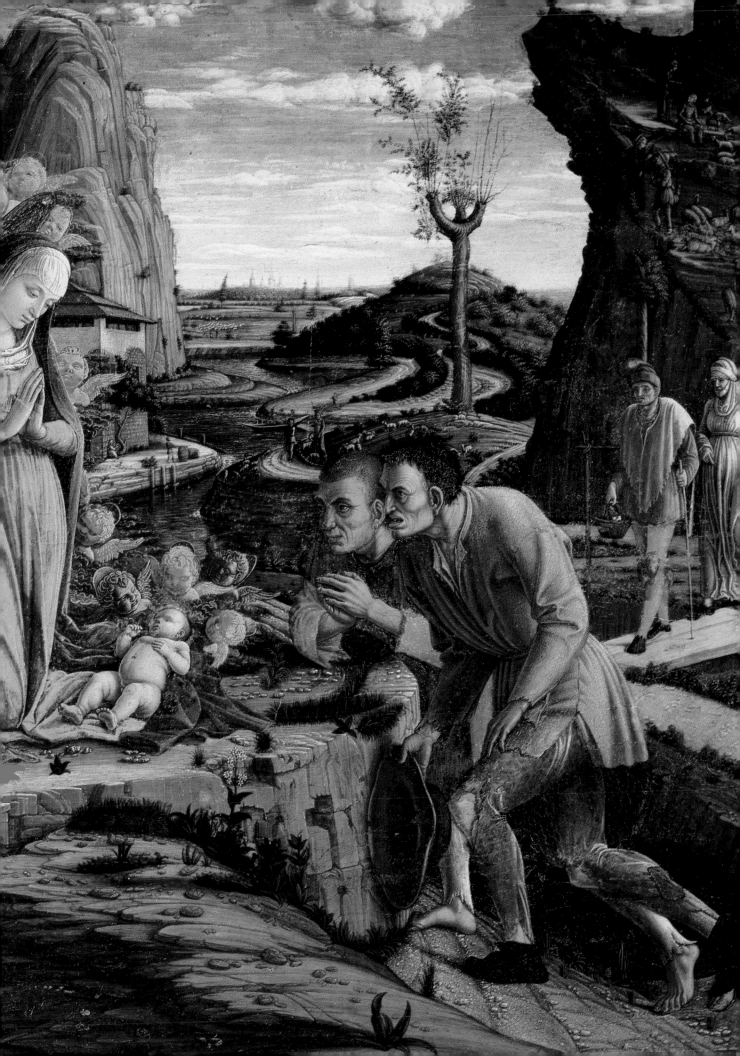

12

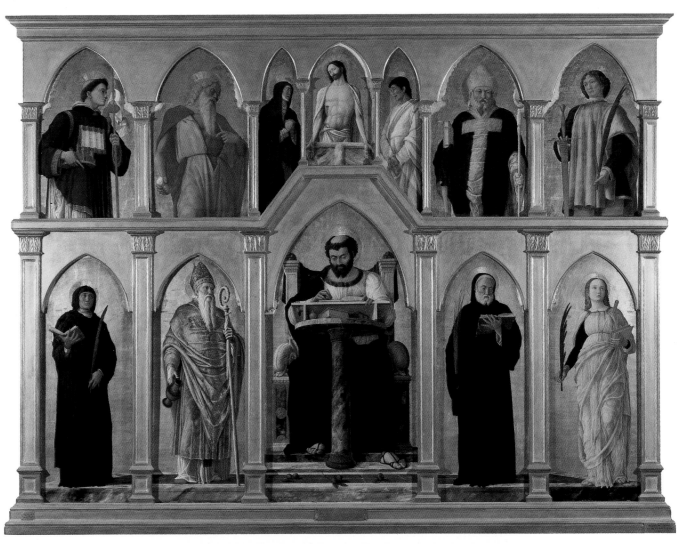

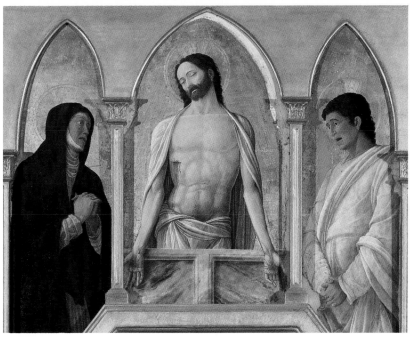

23-25. Polyptych of St Luke and details (after recent restoration)
178 x 227 cm
Milan, Brera Gallery

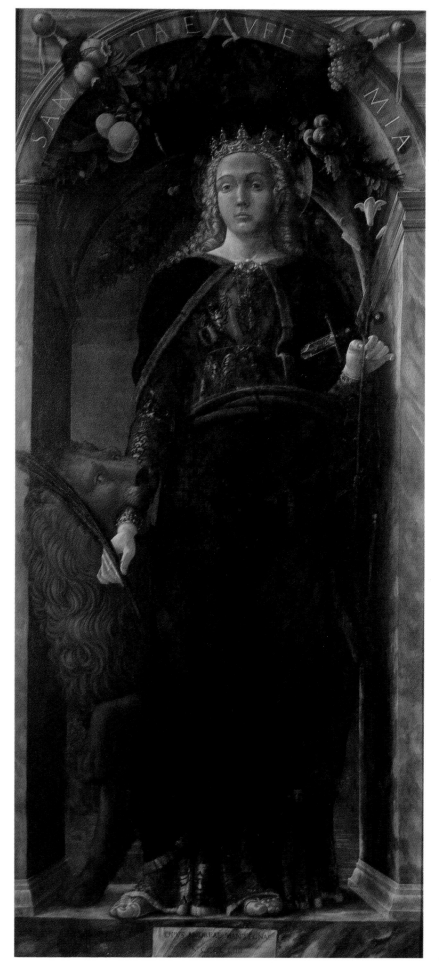

*26. St Euphemia
174 x 79 cm
Naples,
Capodimonte
National Gallery*

*27. San Zeno
Altarpiece
480 x 450 cm
Verona, San
Zeno.
The predella
panels are 19th-
century copies;
the originals are
now in the Louvre
and the Musée
des Beaux-Arts of
Tours*

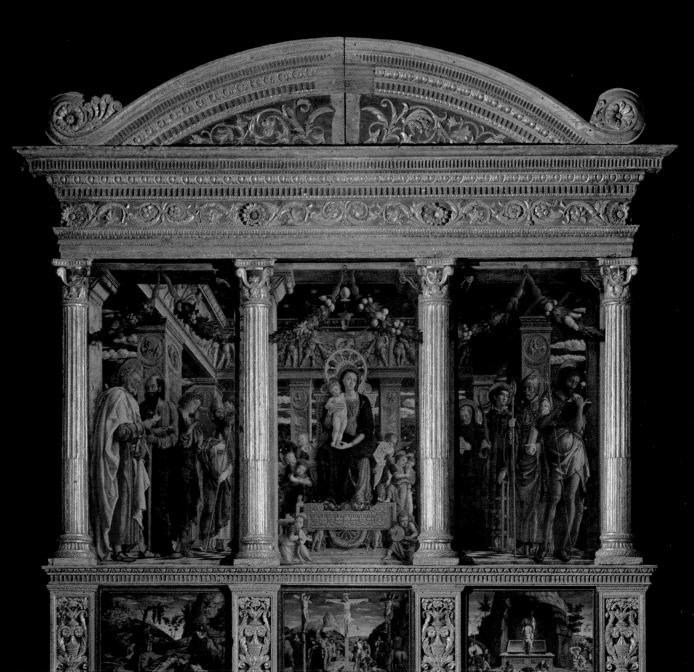

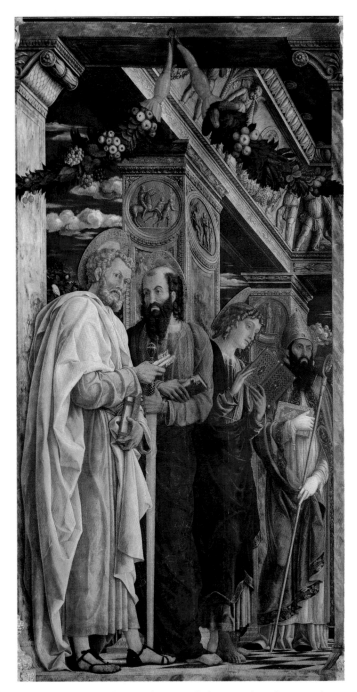

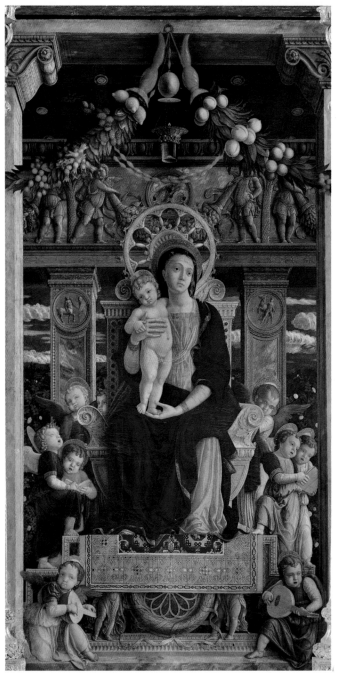

the artistic interdependence of the two brothers-in-law: the technical innovations and organization of the Paduan painter and the pre-eminence of the Venetian in the field of light and colour.

This is confirmed in the two versions of the *Presentation at the Temple*; the Berlin painting by Mantegna and the one in Venice by Bellini. Something of Squarcione's fierce expressiveness is evident in the face of Mantegna's High Priest (an element which is toned down in the Bellini version) and this, together with the Donatellian facial type of the Christ Child, points to the Paduan origins of both paintings. The foreshortened pose of Mantegna's Christ Child (less evident in the Venice version) is seen at an angle in relation to the back of the 'pictorial cube': by placing the Christ Child on the parapet the artist gives a measure of the space behind

28. *San Zeno Altarpiece*
detail of the left part showing Saints Peter and Paul,
St John the Evangelist and St Zeno
220 x 115 cm
Verona, San Zeno

29. *San Zeno Altarpiece*
detail of the central part with the Madonna and Child
Enthroned
220 x 115 cm
Verona, San Zeno

30. *San Zeno Altarpiece*
detail of the right part showing Saints Benedict,
Lawrence, Gregory and St John the Baptist
220 x 115 cm
Verona, San Zeno

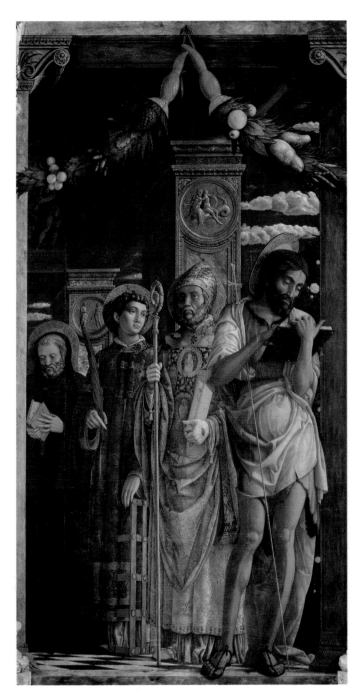

31, 32. San Zeno Altarpiece
details of angels from the central part

while at the same time projecting the Child into our space. This creation of a bridge between the work of art and the spectator is only evident in the Mantegna version in Berlin. Only the spatial device of the ledge will appear again in Bellini's work.

Furthermore, in the Berlin *Presentation at the Temple* the face emerging from the dark to the right of the painting is thought to be a self-portrait of Mantegna. It is not unlike that other possible self-portrait to the far left of the Eremitani fresco of *St James before Herod Agrippa*. It also has some similarity with the Colossal Head which Mantegna had painted for the Ovetari family on the outer wall of their chapel. Despite the discrepancies with the known *Self-portrait Bust* in bronze in Mantegna's funerary chapel in Mantua, it is difficult to deny that Mantegna has included himself in the Berlin canvas. And, if one accepts that the woman to the far left of the painting is a portrait of his wife it seems plausible that it is connected with the marriage of the painter. However, the present writer believes that, amongst the Ovetari chapel frescoes, there is a more likely candidate for Mantegna's self-portrait — the face in the medallion next to the pulpit in the scene of the *Preaching of St James*.

33. *Crucifixion*
central panel of the predella of the San Zeno Altarpiece
67 x 93 cm
Paris, Louvre

34. *Crucifixion*
detail of the grieving women

18

35. Agony in the Garden
63 x 80 cm
London, National Gallery

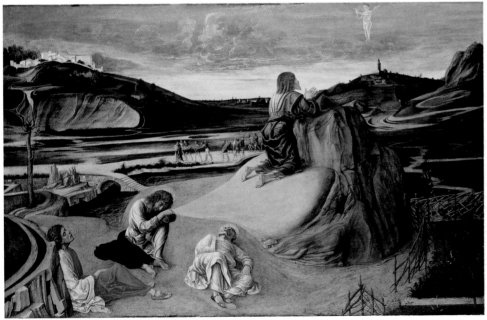

36. Giovanni Bellini
Agony in the Garden
London, National Gallery

37. Agony in the Garden
detail of Judas who leads the
soldiers to Jesus

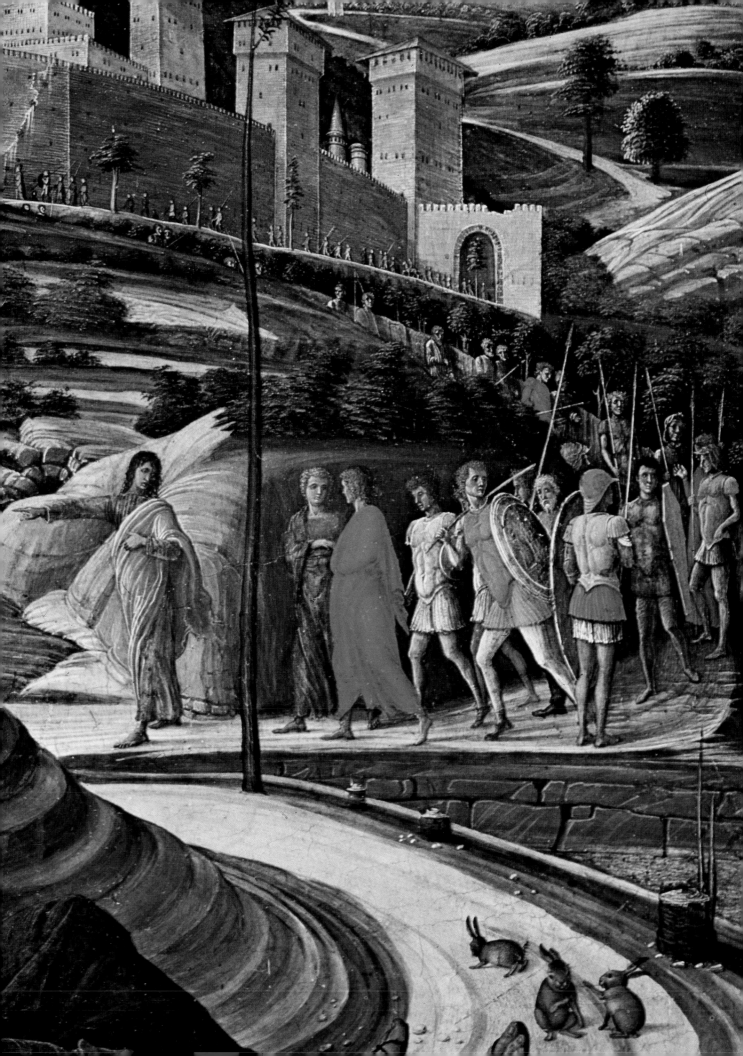

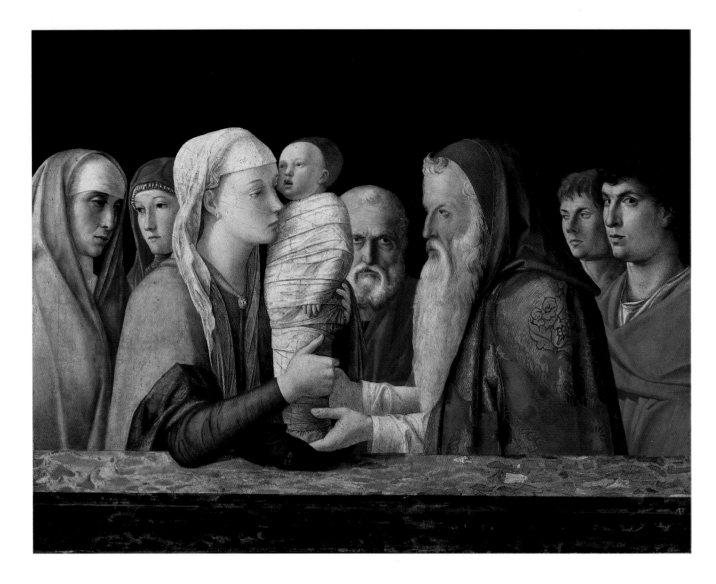

And so to that other early masterpiece of the young Mantegna, the San Zeno altarpiece in Verona, painted between 1457 and 1460. Although the basic format of the painting is essentially that of the late Gothic polyptychs it nevertheless breaks new ground in the way this traditional scheme is handled. The stage upon which the holy gathering takes place is set against an 'open air' background analogous in concept to the two final episodes of St Christopher at the Eremitani church. Even the carpet draped over the window-sill in the *Martyrdom of St Christopher* is identical to the one in the Verona altarpiece. The garlands suspended from the proscenium which appear to thread 'between' the simulated columns of the painting and the actual wooden ones of the frame, dissolve the idea of the fourth wall of the traditional perspective box. The spatial games of this painting have come a long way from Brunelleschi's method of projecting the painted image onto an ideal plane. Perspective has now become a sophisticated means of achieving concrete reality.

In the San Zeno altarpiece there is a merging of the real and the painted world. This is very apparent in the

38. Giovanni Bellini
Presentation at the Temple
Venice, Querini Stampalia Gallery

predella panels which are no longer so much 'windows' onto the world as a transposition of the world itself into a mystery play which is enacted before our eyes. The figures cropped off by the frame in the foreground of the *Crucifixion*, in the Louvre, emphasise that this holy play has begun; they are like a couple of extras surprised on stage by the raising of the curtain that had until then concealed the tragedy of life and death (A.M. Romanini).

The device of the truncated figures brings to mind Flemish painting as do the expressions of howling grief of some of the 'actors' which can be compared with similar figures in the work of Van der Weyden. The San Zeno altarpiece is lit by that same timeless quality of light (similar to that of Piero della Francesca) which also suffuses the last Ovetari frescoes and which has its origins in Flemish painting.

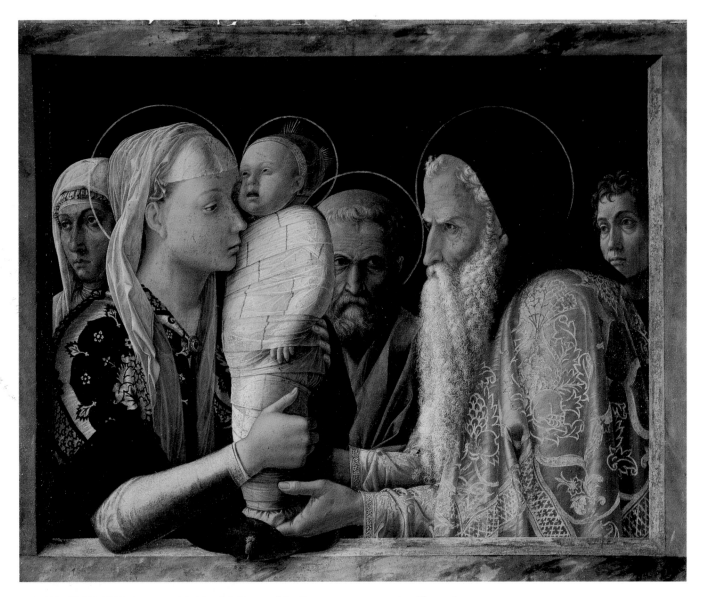

39. Presentation at the Temple
67 x 86 cm
Berlin-Dahlem, Gemäldegalerie

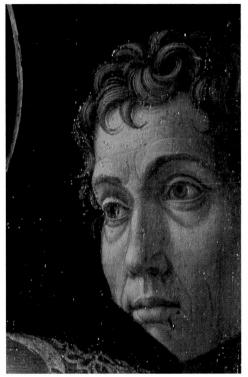

40. Presentation at the Temple
detail of the presumed self-portrait

23

From Padua to Mantua

In 1456 Marchese Ludovico III Gonzaga, Lord of Mantua, invited Mantegna to become his court painter. Two years later the master and his assistants were working on frescoes in the Gonzaga palaces of Cavriana and Goito. Nothing now remains of these cycles, nor of subsequent work done in other Gonzaga castles. It is just possible (but opinion is by no means unanimous) that there are echoes of these lost frescoes in the engravings of the two *Bacchanals* which, together with the *Battle of the Sea Gods*, constitute the very best of the twenty or so engravings attributed to Mantegna and which were so admired by Vasari and others.

As early as 4 May 1459 Ludovico Gonzaga had written to Mantegna that the chapel in the Castle of San Giorgio, which was the Marchese's principal Mantuan residence, had been prepared in accordance with the artist's instructions. In 1565 Vasari saw — or described without actually seeing — a work by Mantegna in this chapel (which was subsequently altered and then demolished) which today most scholars identify as the Triptych in the Uffizi the earliest documentation for which dates from 1587. Some assign it to the first or second of Mantegna's Florentine sojourns which took place in 1466 and 1467 respectively. However, that thesis is weakened by the firm stylistic evidence which links the painting with Mantegna's last Paduan works.

The Triptych is a problematic work not least because it lacks cohesion (the frame is nineteenth century) and there is a marked disparity between the setting of the *Circumcision* and that of the *Ascension* and the *Adoration of the Magi*. The concave surface of the latter might well relate to the shallow niche of the chapel's apse.

For stylistic reasons and because of its dimensions the Triptych can be related to the *Death of the Virgin* (Madrid) which once included the fragment of *Christ with the Soul of the Virgin* (Ferrara). This leads one to suppose that there were several works by Mantegna in the palace chapel including paintings whose settings were analogous with that of the *Circumcision*. The sur-

viving works are all of high quality, as we would expect from Mantegna, but the *Death of the Virgin* should be singled out for praise. Here reds, yellows, crimsons, greens and blacks are juxtaposed with a boldness which anticipates El Greco while the subtlety of the landscape (the same which is seen from the Camera degli Sposi suggesting that the chapel was beneath it) and the pool of light at the centre of the floor would have been greatly admired even in the Venice of Carpaccio's day; the Venetian painter was a mere baby when this panel was painted.

The architectural setting of the *Circumcision* seems to reappear, in a ruined state, in the meticulously executed *St Sebastian* in Vienna. In the top left-hand corner of this painting a cloud in the form of a horseman sails across the sky; it has been identified as King Theodoric who is quite unconnected with the martyred saint. Could he not rather be a horseman of the Apocalypse together with his two companions and therefore symbolic of the plague from which St Sebastian was believed to deliver the faithful? Whatever the meaning it is very similar to a Romanesque relief on the facade of the church of San Zeno in Verona whose cityscape is probably depicted in the background of the painting. The Greek inscription (meaning "work of Andrea") was almost certainly conceived in the humanistic climate of Padua rather than Mantua.

A contemporary work is the portrait of *Cardinal Mezzarota* (Berlin) probably painted during the Ecumenical Council of 1458-60. The enamelled solidity of this work softens in the portrait of *Francesco Gonzaga* (Naples) painted between 1460-61 when the sitter was created an Apostolic Protonotary. The delicate but precise brushstrokes, breathing life into the sulky candour of the young prelate appear again, almost with the authority of a signature, in the *Profile of a Man* in Milan which recent scholars have unfairly rejected as being by Mantegna's hand.

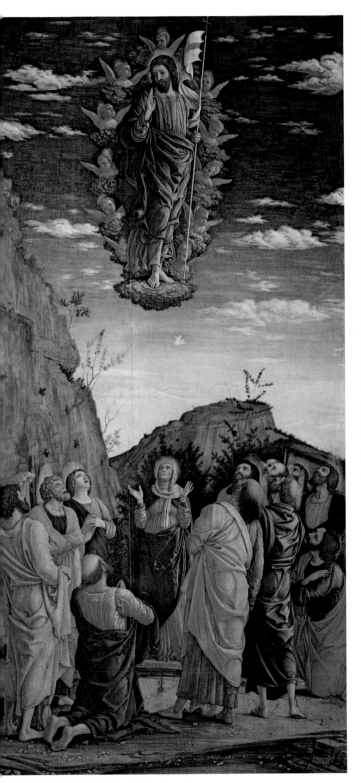

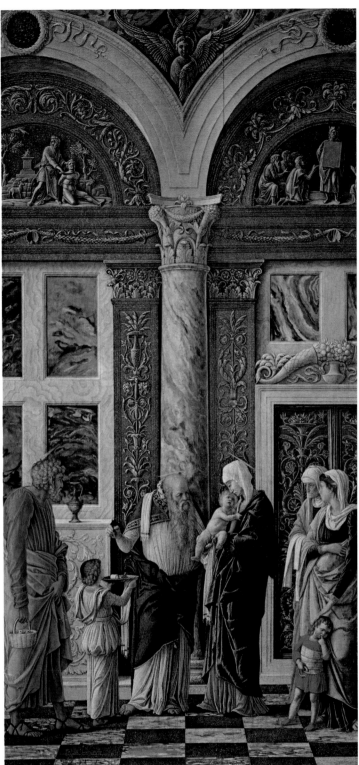

41. *Ascension*
86 x 42.5 cm
Florence, Uffizi

42, 43. Circumcision and detail
86 x 42.5 cm
Florence, Uffizi

44. Adoration of the Magi
76 x 76.5 cm
Florence, Uffizi

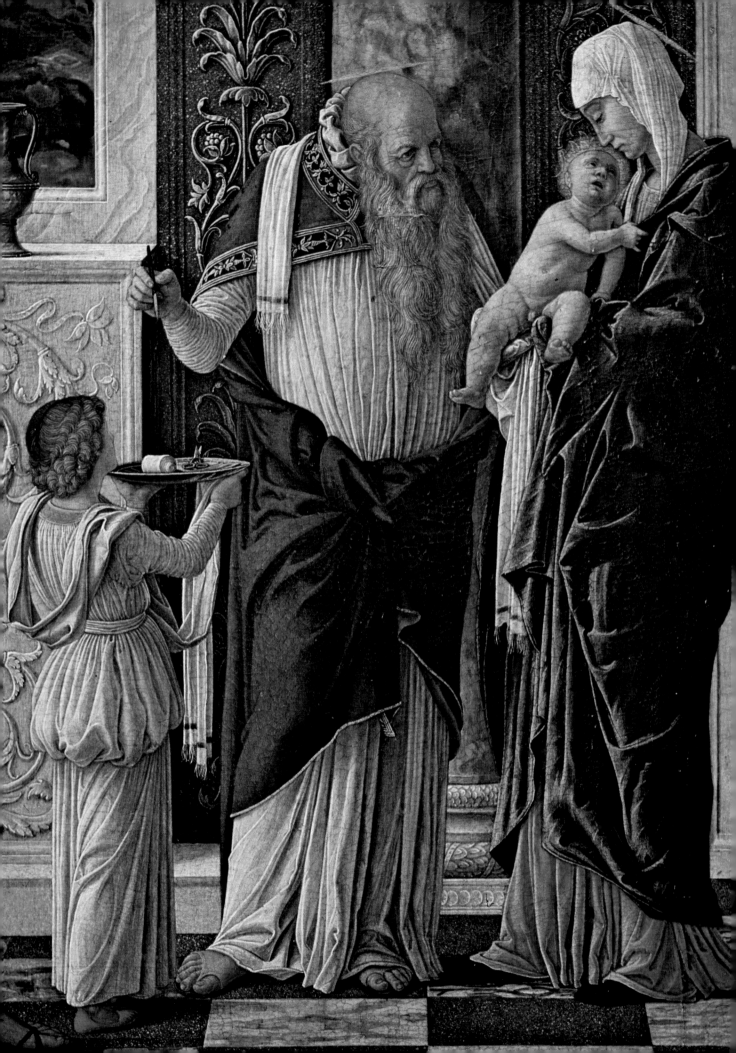

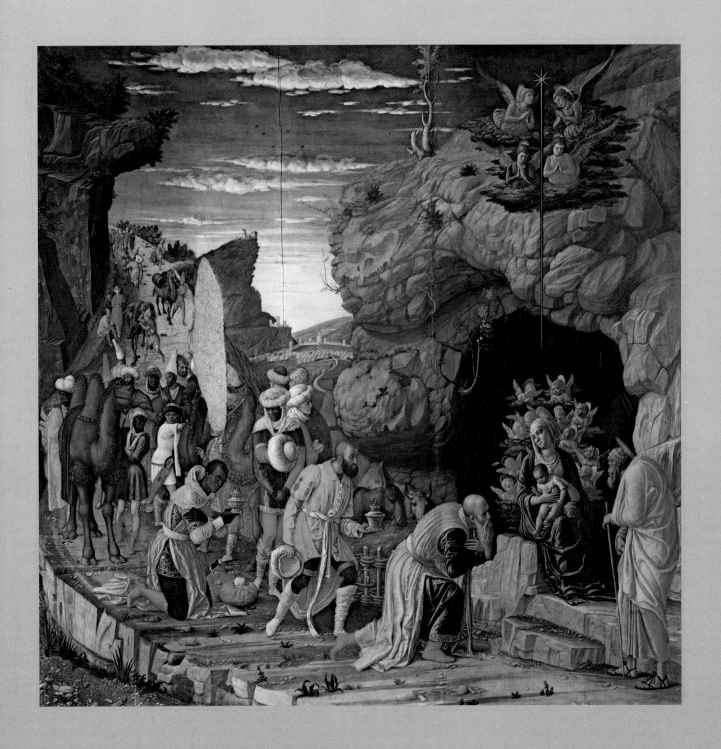

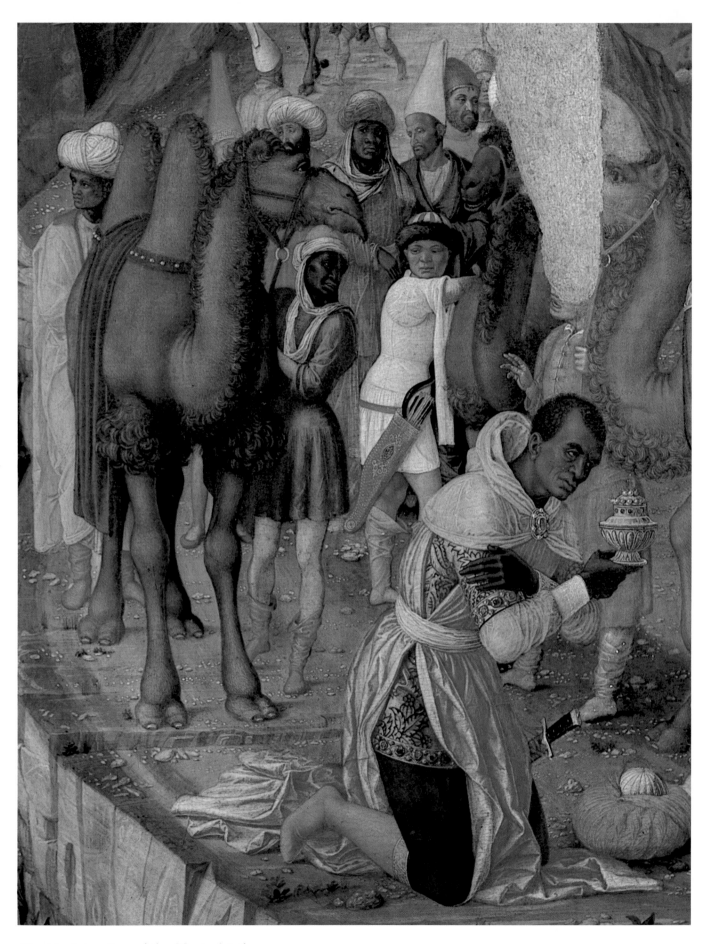

45, 46. *Adoration of the Magi, details*
Florence, Uffizi

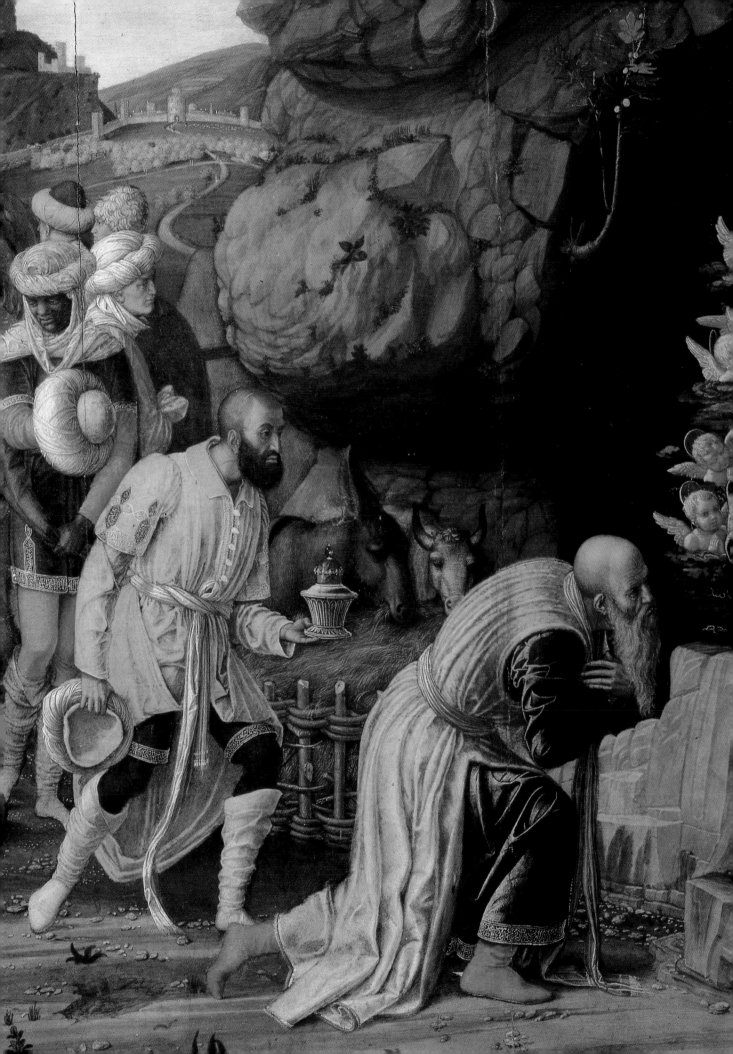

48. Diagram which
reconstructs the original
arrangement of the
Ferrara and Madrid
paintings

47. Christ with the Soul of the Virgin
27 x 17 cm
Ferrara, Baldi Collection

49. Death of the Virgin
54 x 42 cm
Madrid, Prado

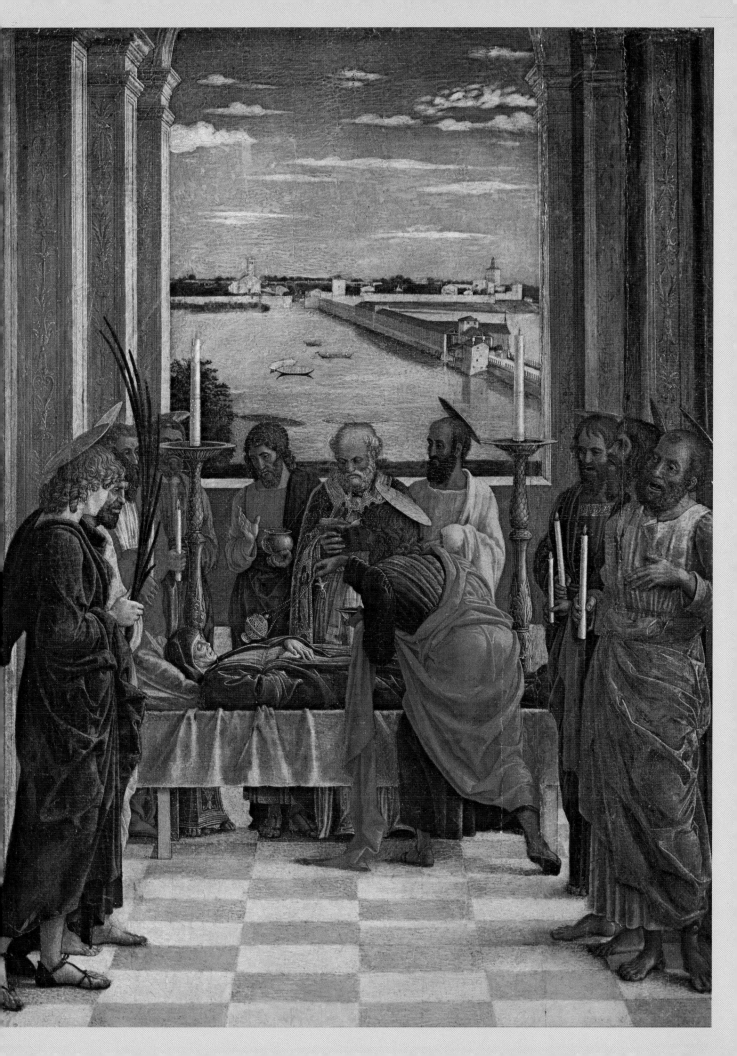

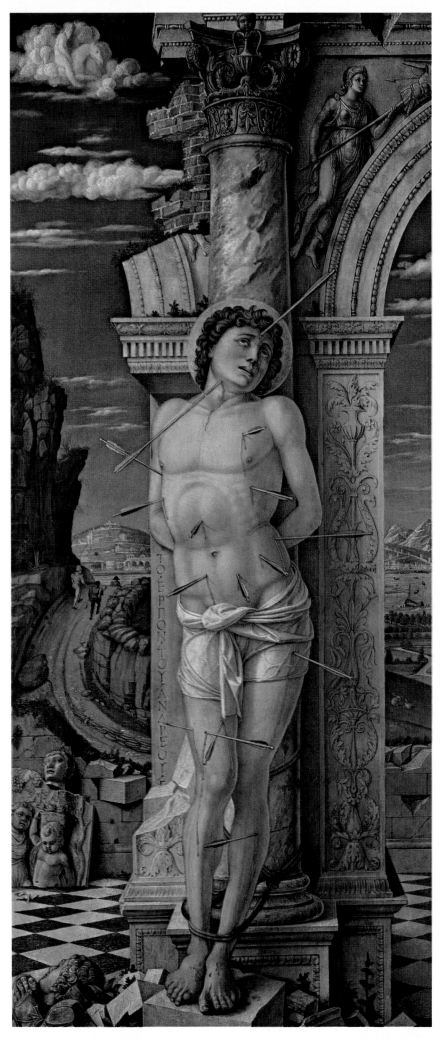

50. *St Sebastian*
68 x 30 cm
Vienna,
Kunsthistorisches
Museum

51. *St Sebastian*
275 x 142 cm
Paris, Louvre

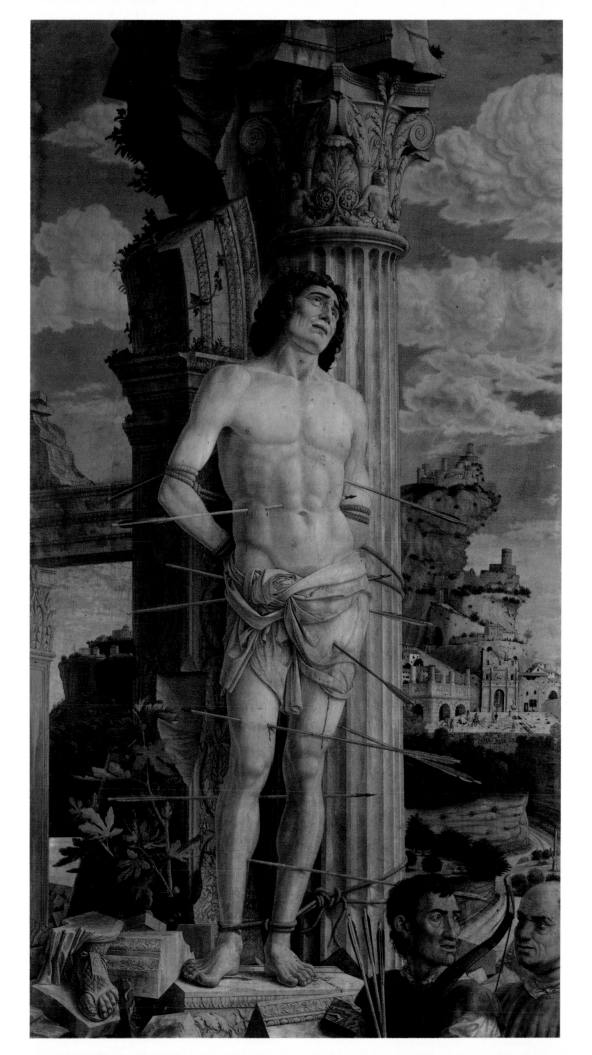

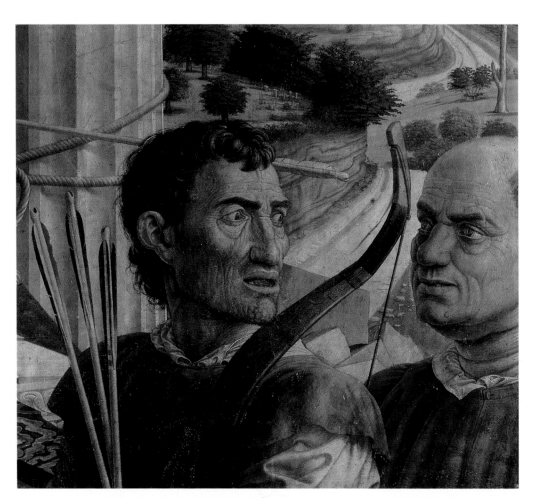

52. St Sebastian, detail
Paris, Louvre

53. Profile of a Man
33 x 25 cm
Milan, Poldi Pezzoli Museum

54. Portrait of Francesco Gonzaga
25.5 x 18 cm
Naples, Capodimonte National Gallery

55. Portrait of the Protonotary Carlo de' Medici (after recent restoration)
40.5 x 29.5 cm
Florence, Uffizi

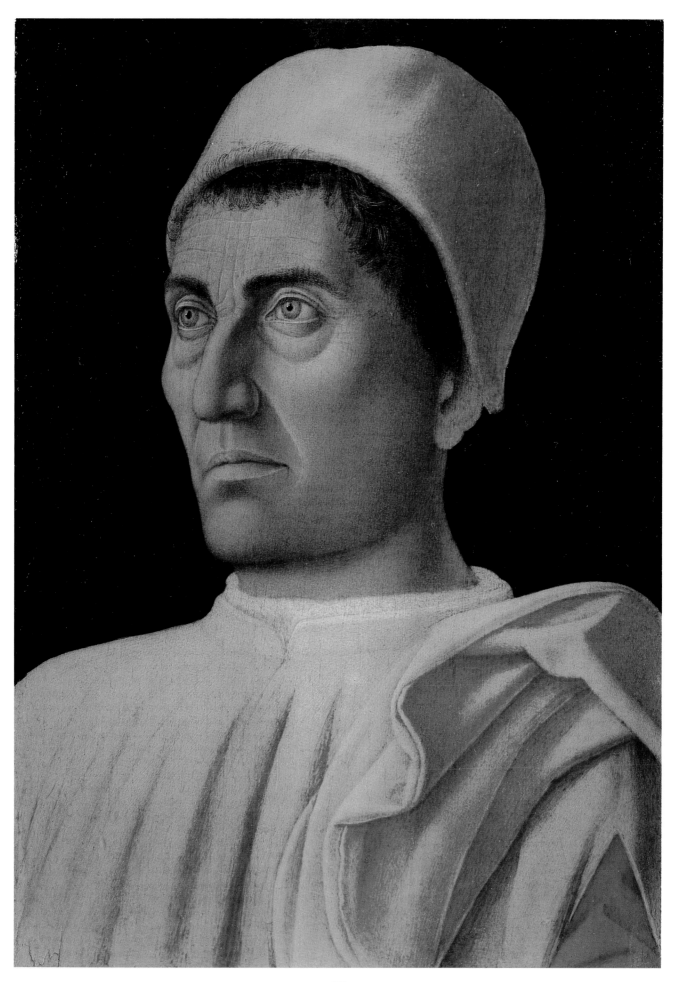

The Camera degli Sposi

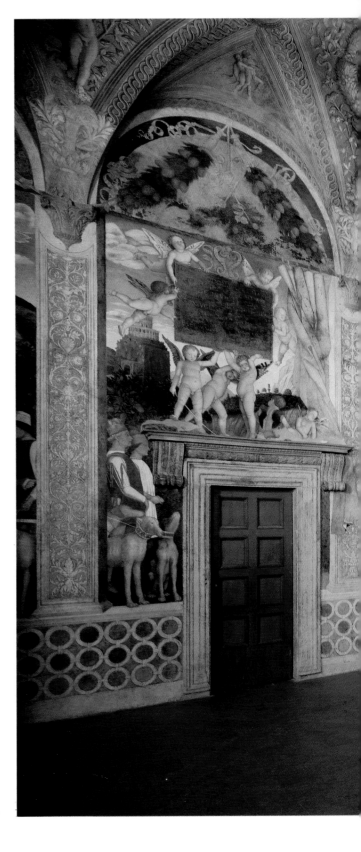

We now come to that Mantuan room which is well-known and admired today but which so nearly fell victim to that series of misfortunes which caused it material damage and even conspired to exclude it from the history of art. Originally intended as the bedroom of the Marchese Ludovico, who also used it as a small audience chamber, it became, shortly after his death, a storeroom for precious objects. This is probably why it seems that Vasari was unable to visit it. Then the damage done when the Imperial troops occupied the castle in 1630 was compounded by a long period of neglect until about 1875. We have only the barest information concerning the early restoration of the frescoes up to 1941; suffice it to say that the restoration projects were numerous and inadequate. The most recent, finished in 1987, has finally rendered the frescoed room as complete as it will ever be.

The decoration of this almost cube-shaped room (the sides each measure about 8.05 metres) in the north tower of the Castel San Giorgio in Mantua includes the ceiling in the centre of which is the famous *trompe l'oeil* circular 'opening' with its foreshortened balustrade enlivened by women, putti, a terracotta vase and a peacock. The whole illusionistic oculus is enclosed within a circular garland which is in turn contained by a square stucco frame. This is connected to eight lozenge shapes which then fan out into twelve pendentives. The frames of these sections, the medallions depicting busts of Roman emperors in the lozenges and the mythological scenes in the pendentives are painted in grisaille, simulating marble reliefs backed by gold mosaic. The fictive frames converge on the corbels placed above the painted pilasters on the walls of the room. Each wall is divided by the pilasters into three arched bays and around the base of the room runs a painted dado.

In the twelve lunettes above the frescoed scenes hang garlands bearing the emblems of the Gonzaga family. On the level of the corbels which, together with the cornices over the door and the fireplace, constitute the only carved stone elements in the room, there are painted curtain rails between one pilaster and another from which hang fictive leather curtains embossed with

56. The Camera degli Sposi (after recent restoration) Mantua, Ducal Palace

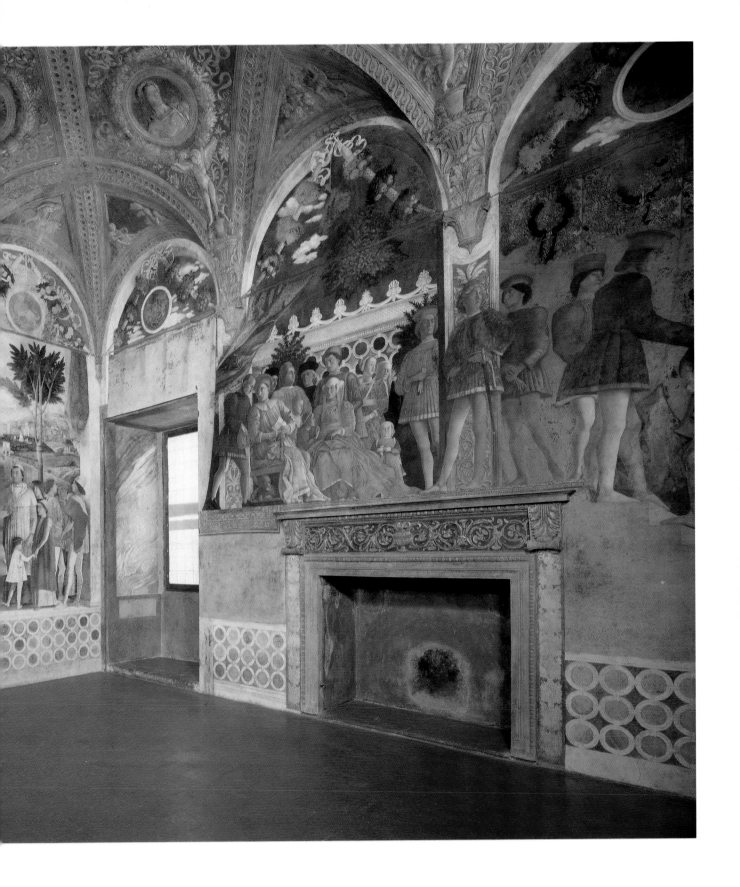

gold designs and lined in blue. On the east and south walls the curtains are lowered. On the two other walls they are drawn back to reveal, on the north wall, the Court — Marchese Ludovico, his wife Barbara of Brandenburg, their children, relations and other personalities —, and on the west wall the *Meeting* where Ludovico reappears together with a prelate and their entourage. Behind them stretches a landscape dotted with hills and citrus trees, while grooms, horses and dogs are in attendance nearby.

So, the fresco decoration transforms the room into a pavilion which opens up onto nature. The brilliant use of painted architectural elements creates the illusion of a deep vault although in reality it is only a slightly coved ceiling. Like the dome of the Pantheon in Rome, a key building to Renaissance artists, Mantegna has created a circular opening to the limitless vastness of the sky. Furthermore, if the *Meeting* is meant to be taking place just outside the pavilion, the *Court* is apparently gathered on a terrace jutting out from it. This is closed off at the back by a parapet reminiscent of Donatello's High Altar at the Santo in Padua. The terrace is extended on the

57, 58. Camera degli Sposi: the ceiling oculus with detail

59. North wall of the Camera degli Sposi: The Court

right to a short flight of steps. Descending these into an antechamber the view is partially obscured by yet another curtain through which we glimpse a sunny courtyard with builders at work. It is a composition of great clarity and immediacy.

Even after decades of research the interpretation of the subject matter is still far from being resolved. Various hypotheses have been thrown up by this scholarly debate including the rejection of the widely held view that the scenes refer to specific occasions of importance to the Gonzaga family.

Be that as it may, we have long known that the *Meeting* commemorates the Marchese Ludovico greeting his son who had been made a cardinal in 1461 and who has grown so stout that it is difficult to make the connection with the youthful protonotary in the Naples por-

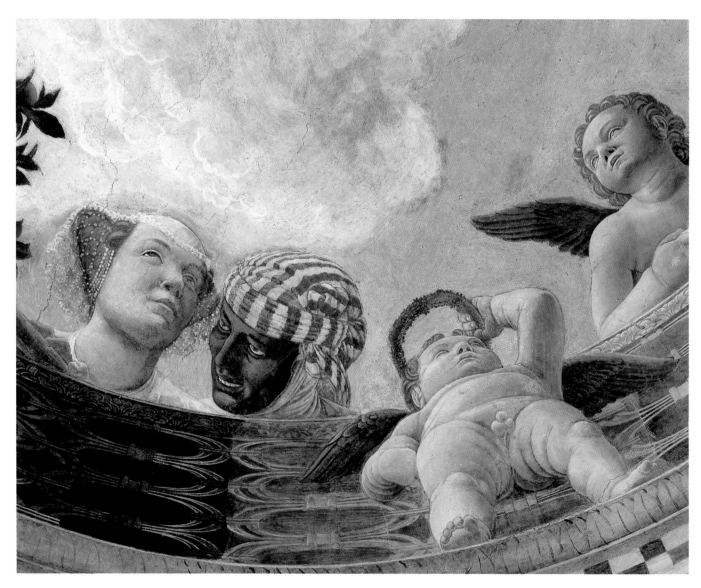

38

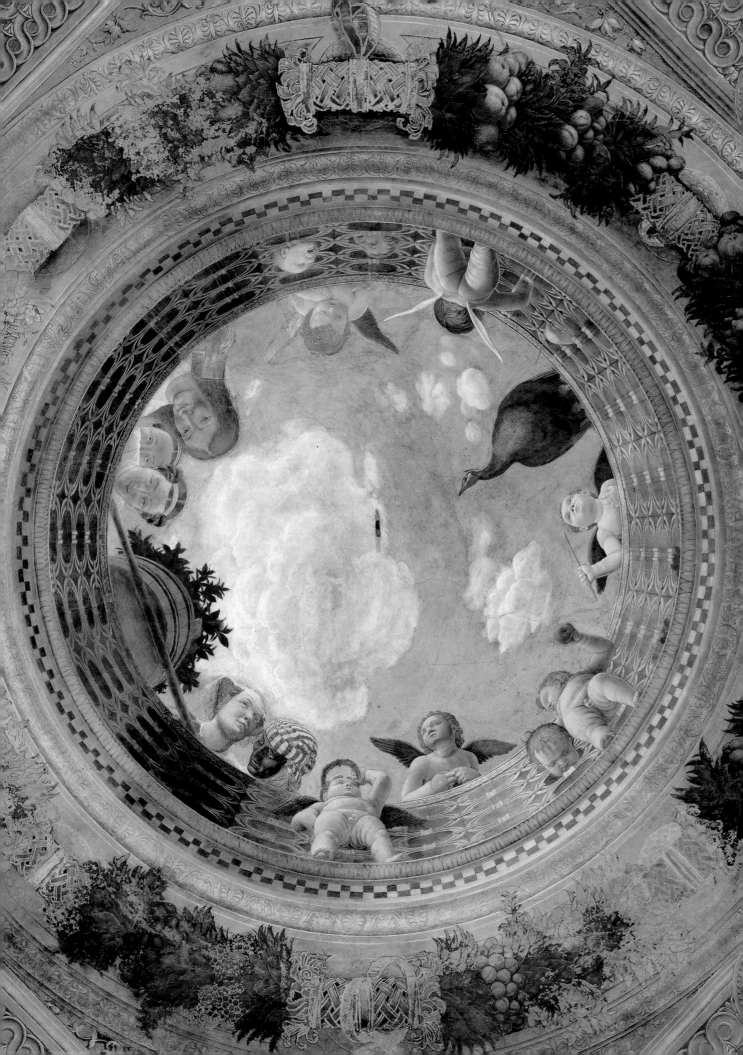

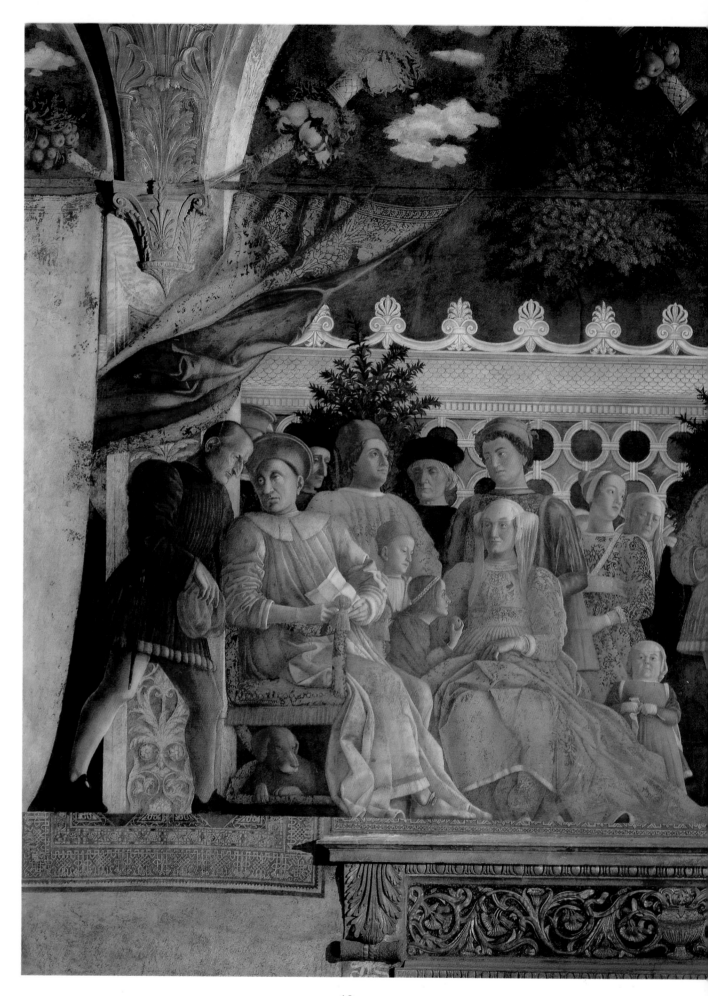

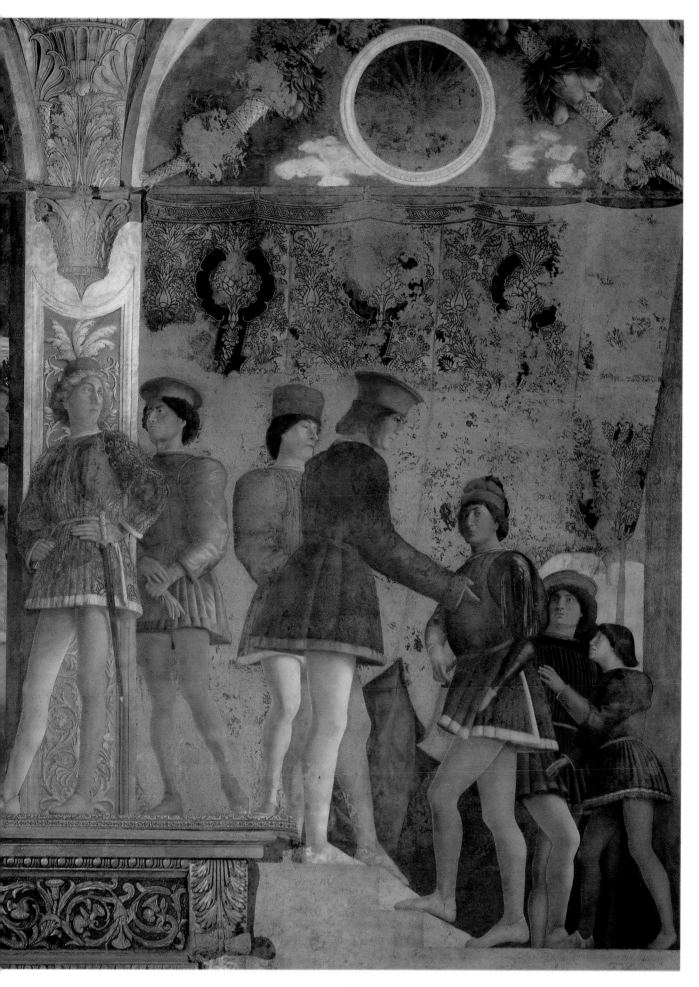

60. The Court, identification of the figures:
1) Marsilio Andreasi (?), secretary of Ludovico III;
2) Ludovico III; 3) Gianfrancesco, third son of
Ludovico III; 4) the protonotary Ludovico (?);
5) Paola (?), youngest daughter of the Marchese;
6) Rodolfo, fourth son of the Marchese; 7) Barbara
of Brandenburg; 8) Barberina Gonzaga (?)

61. The Court, detail

trait. It is, however, unclear if this is the meeting which took place on 1 January 1462, immediately after Francesco was raised to the purple, or that of August 1472 when His Eminence returned to Mantua to assume the titular cardinalship of Sant'Andrea. In the first case the prelate was coming from Milan, in the second from Bologna. To complicate our choice, the city in the background is Rome: a very idealised Rome, where the Colosseum, the pyramid of Caius Cestius and the Ponte Nomentano are recognizable. Perhaps Rome is intended here as a symbol of that ultimate goal for the Cardinal — the very highest of ecclesiastical offices. Those who support the 1472 meeting push forward the dating of the entire fresco decoration to that year or slightly earlier, maintaining that the documents which suggest an earlier date refer to similar, but as yet unidentified, decorative projects.

The recent restoration has revealed a procession of the Magi in the left part of the west wall. The figures are reduced to mere shadows because of the unstable method of painting in egg tempera onto dry plaster and the grime had then concealed them totally. It is supposed that the addition of the Magi serves to convey the fact that we are in winter — the Christmas period of 1461-62 to be exact — despite the proliferation of vegetation. In fact the plants growing so luxuriantly on the west wall are orange trees, and oranges ripen at the end of the year. It is, though, the presence of the Magi which removes all further doubt and it now becomes hard to deny the correlation between the beginning of the fresco cycle and the inscription "1465 d. 16 iunii" (16 June 1465) on the window embrasure of the north wall. Especially now that it turns out that the writing is not incised onto the wall, as was once thought, but is painted to look as if it is scratched onto the surface — an authentic touch of simulation so typical of Mantegna.

It is thanks to R. Signorini that we have not only the discovery of the Magi but also the identification of a likeness of Mantegna in the features of an ornamental mask incorporated into a painted pilaster on the west wall to the right of the door. This discovery makes good what was thought to be an almost embarrassing omission of

the artist himself from the personalities depicted. For more than a century it was supposed that the figure in the Meeting second from the right and wearing a purple-coloured hat was Mantegna but it is now identified as a portrait of Christian I of Denmark. Likewise, the figure next to him, hatless and with dark hair, long firmly thought to be a portrait of Leon Battista Alberti, is now seen as the Emperor Frederick III of Hapsburg.

The paper held in Cardinal Francesco's right hand bears Mantegna's signature but the rest remains illegible, despite the recent careful cleaning of the fresco. This is a great pity especially because it could have provided a clue to help us decipher the meaning of the Court scene. The latter is not merely a group portrait of the Gonzaga family (minus the Cardinal) — the busy comings and goings in the right half of the painting make that clear enough. It is a widely held belief that the folded letter in the hands of the Cardinal on the west wall is the same letter which appears, opened up, in the hands of the enthroned Marchese in the Court scene. The missive could be that urgent plea for help issued to Ludovico Gonzaga by the Duchess Bianca Maria. Concerned by the rapidly failing health of her husband, Francesco Sforza, the Duchess of Milan appealed for assistance to the Marchese in his capacity as commander of the Milanese army. Sent from Milan on 30 December 1461, the letter arrived in Mantua on 1 January 1462 — the very day set aside for the festivities in honour of the newly elected Cardinal. Loyal to his duties as a soldier, Ludovico renounced the celebrations for the happy conclusion of what had been a lengthy diplomatic scheme and departed for Milan. Shortly after leaving Mantua, at Bozzolo, he met his son who was travelling the same road from the opposite direction and the Marchese informed him of the serious contretemps.

It remains to ask ourselves, when one comes down to it, whether this episode was really worth immortalising in this way, even to the extent of bringing in the Holy Roman Emperor and the King of Denmark? But this, it seems is not the real issue. Apparently, of greater significance is the way Mantegna depicts the presenta-

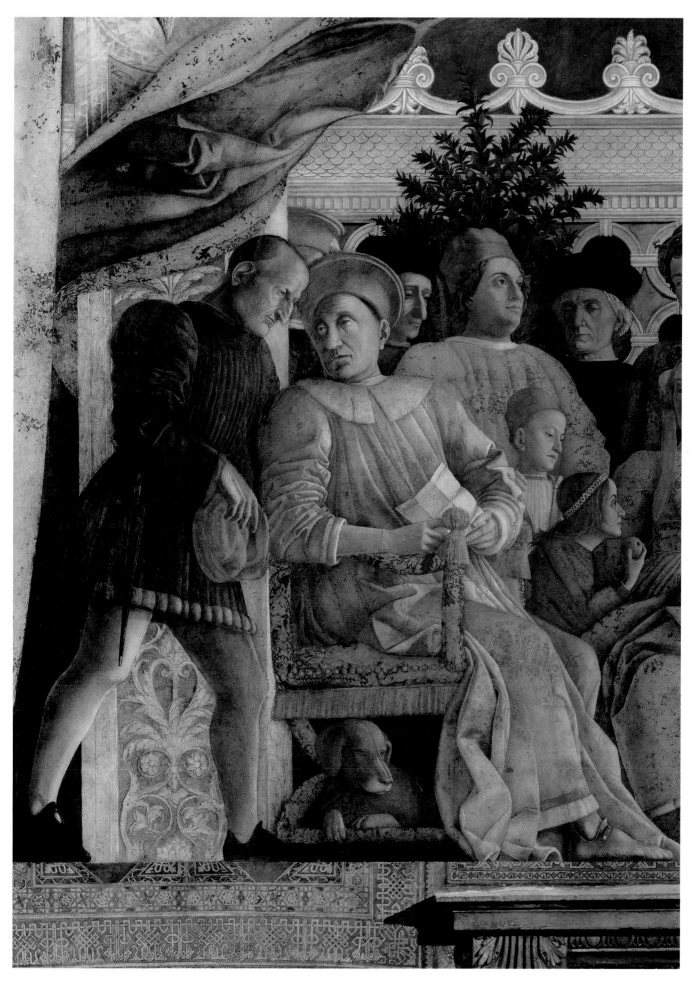

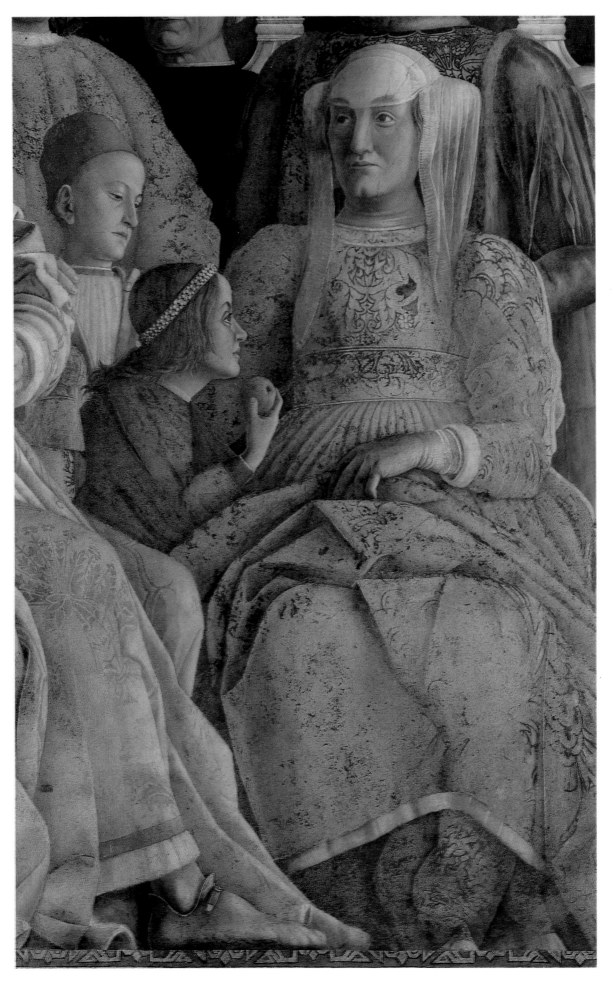

44

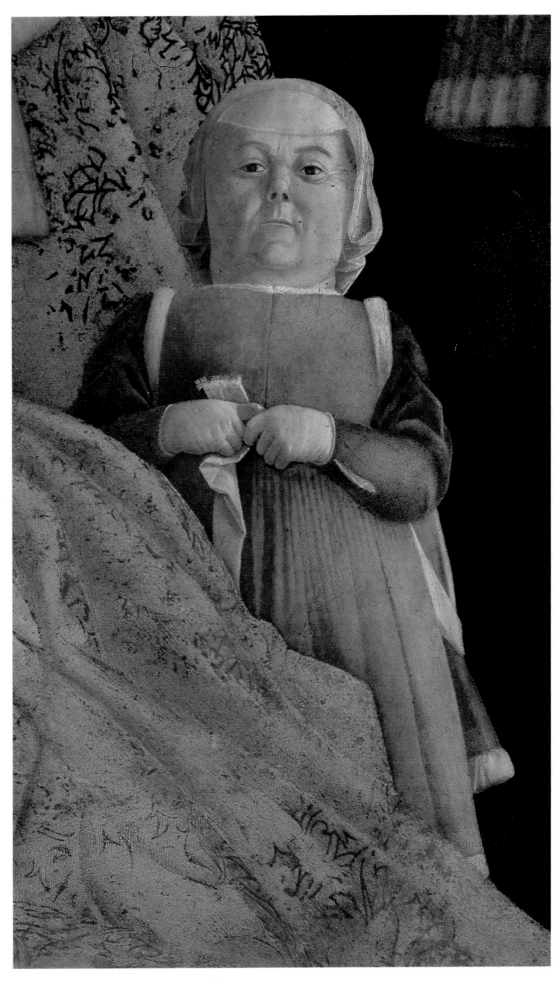

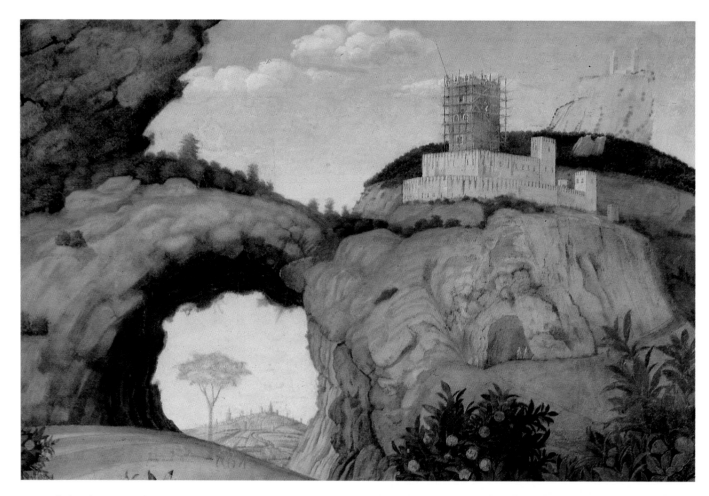

tion of the letter in the *Court* scene. It is open but the address is concealed by the knob of the faldstool on which the Marchese is seated. It has been deduced from this that the seemingly blank letter refers to that "damnatio memoriae" decreed by the Gonzagas against the Sforza family for having impeded the marriage of the Sforza heir to first one and then another of Ludovico's daughters (R. Signorini). While the documentary evidence seems to exonerate the Milanese dukes from any blame in this matter, the archival material is unforthcoming on the reaction of the Gonzaga family unless one can read into this documentary silence a mute and dignified expression of disillusionment in those responsible for thwarting the marriage. And is it really likely that the eminently sensible Ludovico would brood over such an obscure vendetta to the extent of dedicating an important fresco decoration in the heart of his palace to it? Finally, is it logical that the Gonzaga curse of "damnation", "abolition" or whatever, should be directed at the Marchese himself since his own name is 'expunged' from the Duchess's missive — the original letter in the State Archive is addressed to the "domino Ludovico, marchioni Mantue"?

It is to be hoped that the new information gained as a result of the restoration of the cycle will provide us with more credible interpretations than the one outlined above and other, even less tenable 'readings', not examined here.

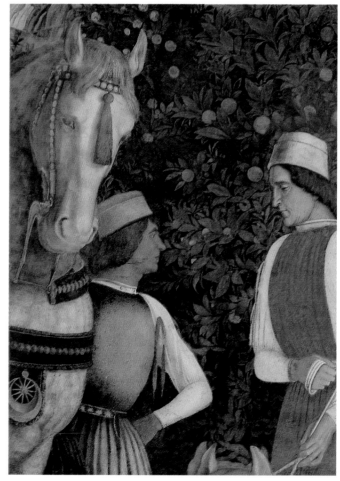

64-66. West wall of the Camera degli Sposi: grooms with horse and two dogs and details

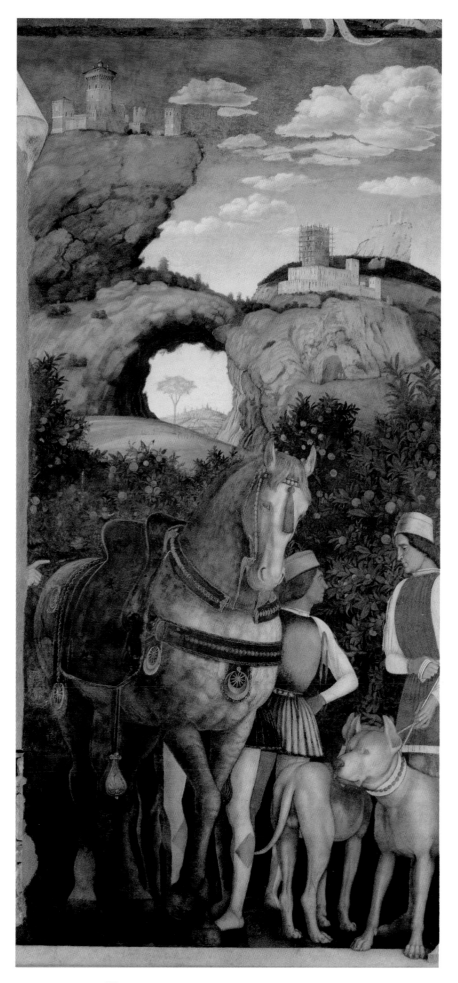

Meanwhile, the much debated problems of technique and chronological sequence of the work have been resolved (M. Cordaro). As is logical, work began on the ceiling which was painted in the traditional fresco technique onto fresh plaster with some of the background painted 'a secco' (that is onto dry plaster) — part of the oculus and the garland which surrounds it, for example. Next came the *Court* scene where Mantegna switched to an unusual oily tempera painted onto dry plaster; the work proceeded from level to level. There followed the east and south walls, decorated with the lowered curtains; here Mantegna returned to the traditional fresco technique as in the *Meeting* wall. This fresco, on the last wall to be painted, was carried out in very small plaster patches — the 'giornate' which each denote a day's work — thus emphasizing Mantegna's slow working methods. This helps explain the almost ten years that he spent on the decoration — a long time, even taking into consideration his employment on other projects.

It seems certain that the cycle was completed in 1474, as we are told in the dedicatory tablet painted above the door on the west wall, even though the repainting of the numbers in the inscription (following the darkening of the original silvering) has called the dating into question.

The recent restoration has determined that the Gonzaga coat of arms flanked by putti on the south wall is probably autograph. What still remains unresolved, however, is the dating of the vertical strip to the extreme left of the *Meeting*; this covers an area which once was clearly painted and from which emerges an enigmatically pointing hand. Beneath the strip, which has been there since the late eighteenth century, there remains no trace of painting.

Neither this loss nor the other lacunae disturb the majesty of the work. This grandeur is imposed through the keenly observed portraits, the solemn and slow-moving actions, the fascinating backgrounds full of lively and learned inventiveness and the homage to the antique past expressed through the 'real' townscapes and those buildings which are figments of Mantegna's classically inspired imagination. It is a nobility at once grave and human, worthy of comparison with Piero della Francesca alone.

Some critics also detect irony, especially in the oculus; however these figures fit in perfectly with the delicacy of the sentiments present on the walls of the room. Note, for example, in the *Meeting*, the touching interlacing of the fingers of the Cardinal and the two young relatives, themselves destined for the ecclesiastical life. It is conceivable that Mantegna was asked to express, on the ceiling, the peoples' affection for the Gonzaga family. The painter imagines these women looking down from above and turning towards the *Court*, expressing confidence in the ruling family. The antiquarian erudition which has led to the recreation of the Roman Pan-

48

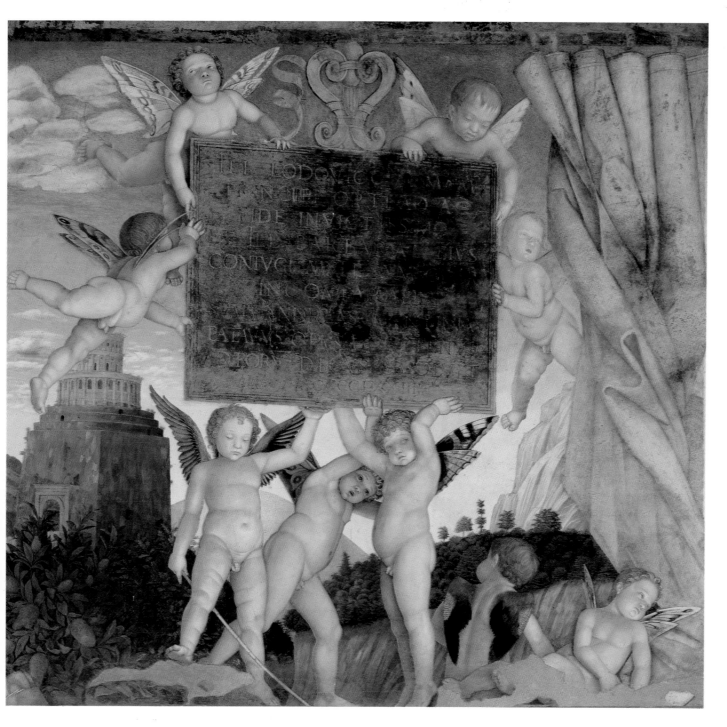

67. West wall of the Camera degli Sposi: detail of the painted pilaster with the artist's self-portrait

68. West wall of the Camera degli Sposi: putti holding the dedicatory tablet

theon in this castle room in Mantua effortlessly dissolves into the ordinariness of every-day life.

In the *Camera degli Sposi* that relationship between painter and spectator, which began in around 1450 in Mantegna's work at the Eremitani church, reaches new heights. With the San Zeno altarpiece the spectator was involved in the space of the 'sacra conversazione' while

now he finds himself at the centre of the space created by the painter and the roles are reversed. It is now the observer who is himself observed by the painted figures, by the Gonzagas themselves. Indeed he is actually spied on from above (A.M. Romanini) thanks to an unprecedented illusionistic trick so intriguing that it was later to become widely imitated. Here perspective is no longer used to project us into the painted world or to project this world towards us. Instead it becomes a tool to physically include the spectator within the scenes for the first time; a perfect synchronization of the living and the painted. The Gonzagas and ourselves are part of the same reality, we inhabit the same space because Mantegna has ensured that the story depicted

49

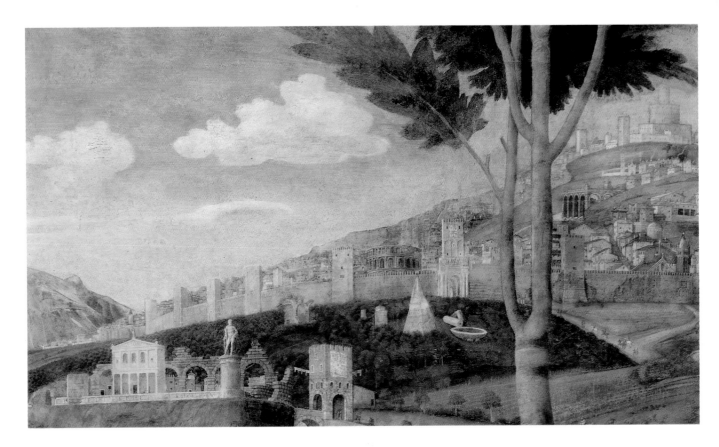

69, 71. West wall of the Camera degli Sposi: The Meeting and detail

(whatever it may be) is not relived so much as lived by us at the very moment of its taking place.

Amongst Mantegna's surviving works only one seems to be contemporary with the *Camera degli Sposi*: the *Portrait of the Apostolic Protonotary Carlo de' Medici* which, although connected by some with the Ecumenical Council held in Mantua 1459-60, seems to belong more plausibly to Mantegna's visit to Florence in 1466. In its self-conscious detachment the Medici prelate is intended to be seen as a classical bust. The strong lines of the face are emphasized by the forceful chromatic modelling and given further definition by cross-hatched highlighting. The stony gaze which sweeps over the observer completes the feeling of a living sculpture.

The mural decoration presumably carried out in around 1478 at the Marchese's residence at Bondanello, near Gonzaga, seems to date from shortly after the completion of the great Mantuan cycle. Archival material suggests that Mantegna was engaged on painting a frieze in one of the rooms of the palace. There is general agreement amongst most critics that the two engravings of the *Battle of the Sea Gods* (already singled out as being amongst the very best of Mantegna's prints) may have some connection with this frieze. The unreliability of the documentary evidence means that we can only

70. The Meeting, identification of the figures: 1) Ludovico III; 2) Cardinal Francesco, second son of Ludovico; 3) Francesco, first son of Federico I; 4) Sigismondo, third son of Federico I; 5) the protonotary Ludovico, youngest son of Ludovico III; 6) Federico I, first son of Ludovico; 7) Christian I of Denmark (?); 8) Frederick III of Hapsburg (?)

guess at the nature of the Bondanello paintings, lost when the building was demolished in the eighteenth century. As for the engraving of the *Battle of the Sea Gods*, we cannot but admire the urgency of the actions and passions portrayed, rendered dramatic by the very nature of the engraving technique which both outlines and breaks up the surfaces, injecting exceptional force into antique forms which, far from fossilized, are brought to life.

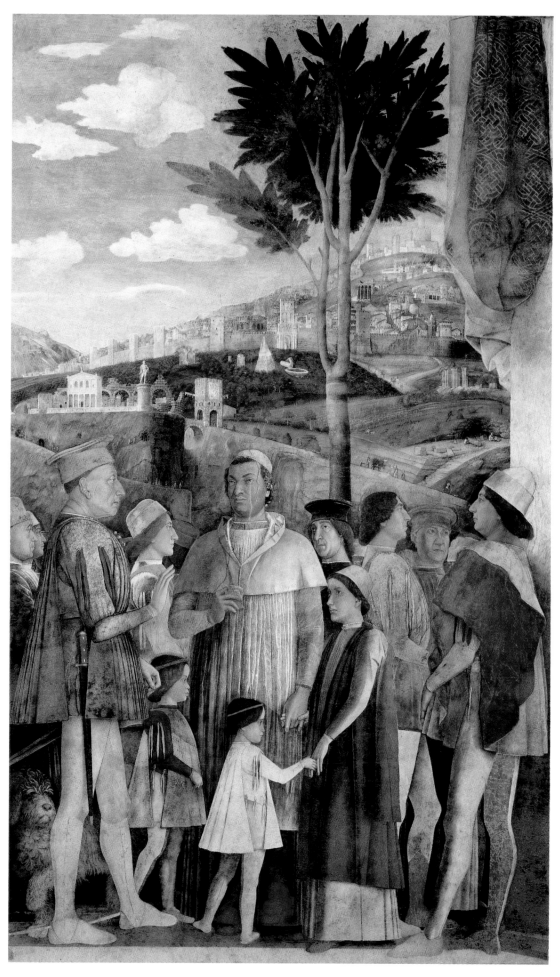

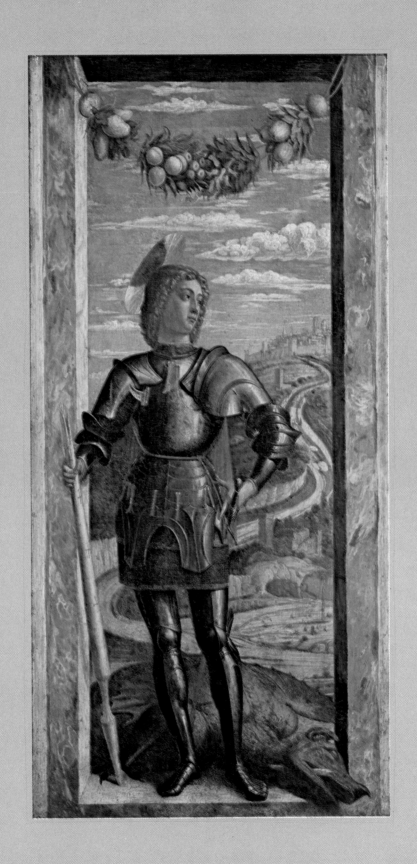

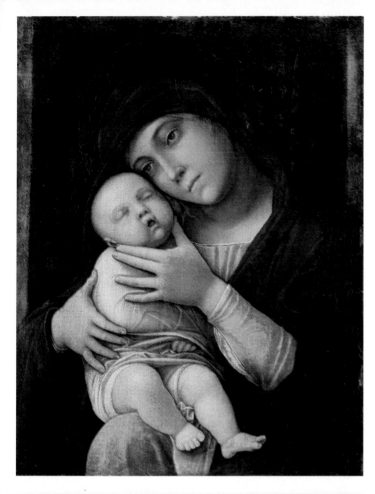

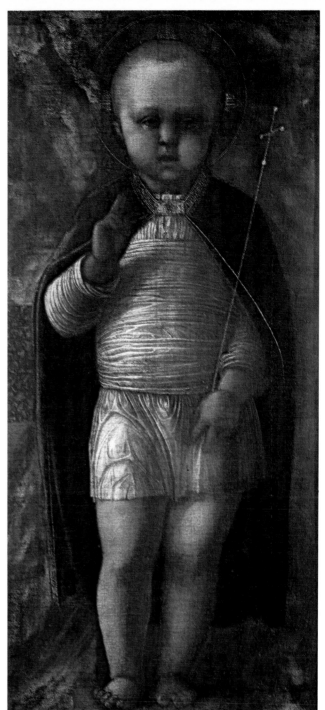

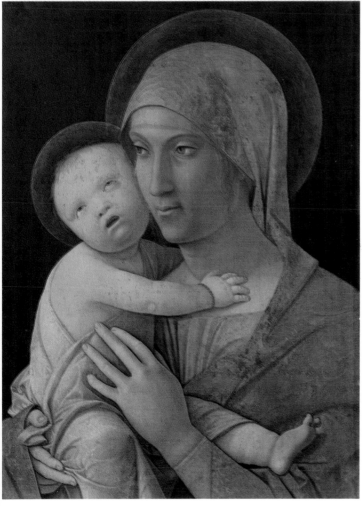

72. St George
66 x 32 cm
Venice, Academy Gallery

73. Madonna and Child
43 x 35 cm
Milan, Poldi Pezzoli Museum

74. Christ Child Blessing
70 x 35 cm
Washington, National Gallery of Art

75. Madonna and Child
43 x 31 cm
Bergamo, Accademia Carrara

The Roman Period

The first infirmities of advancing age, family troubles, the responsiblity of supervising the work at the various residences of his patrons (who were famously obsessed with building projects), and other duties connected with his service at court, left Mantegna little time to produce much else prior to his visit to Rome. In his capacity as court artist he worked on miniatures, designed tapestries, goldsmith work and wedding chests (these 'cassoni' are not autograph but derive, for the most part, from his ideas) and sculpture (although amongst the various pieces attributed to him only the bronze *Self-portrait* has survived recent critical scrutiny). Above all, he was working on the series of canvases depicting the *Triumph of Caesar* which were already under way in 1486.

Some scholars believe that the *Dead Christ* in Milan belongs amongst the few easel paintings of this period; the proposed dating for the work has varied greatly, ranging from the end of the Paduan period (c. 1457) to 1501 or later. We need hardly mention the fame of the perspective construction of this painting whereby the image of the Redeemer appears to 'follow' the spectator around the room through the use of an illusionistic technique similar to that employed for the oculus in the ceiling of the *Camera degli Sposi* but in this case so overwhelming as to eclipse any other expressive element in the picture. Even modern critics are disconcerted by this work, and uncertainty about the date — a span of nearly half a century divides opinion — is matched by an equal disagreement about its aesthetic value, which should not be confined exclusively to an appreciation of the brilliant foreshortening of the body of Christ. Serious consideration of the painting has come up with praise for the light, described as "livid twilight", and the marginally more interesting observation that the rapidly vanishing perspective, beginning at Christ's feet, is powerfully related to the way we are forced to 'discover' the other wounds by following the folds of the drapery (R. Lightbown).

There are those who think the two mourning figures are later additions, as if to justify their lack of cohesion with the rest of the composition (M. Marangoni, 1933). On the other hand, a "Cristo in scurto" (a "foreshortened Christ")·is mentioned among the works still in the

artist's studio at the time of his death in 1506. Even though it might seem odd that such a work was left unsold during Mantegna's lifetime, it was bought shortly afterwards by Sigismondo Gonzaga. But was it the original and can it be identified with the Milan picture? It has never been doubted that the latter is autograph but a number of clues do indicate that there were two versions of the *Dead Christ* (K. Christiansen). The Glen Head version, in a private collection, does not help to solve the question, despite its backing by some Mantegna specialists; it is an inferior copy dating from the late sixteenth century. However, it diverges in several details from the Milan painting and does not include the two mourners. So, if it is an exact copy, it must imply the former existance of another original. This, together with the fact that the condition of the Brera painting is very poor (due to spurious repainting) leads us to suspend judgement on the matter.

On 10 June 1488, Francesco II Gonzaga, who had succeeded as Marchese four years before, on the death of his father Federico I who had himself succeeded Ludovico III in 1478 — wrote a letter of introduction to Pope Innocent VIII on behalf of Andrea Mantegna who was about to leave for Rome.

Before his departure the artist may have made preparatory studies for the four frescoed roundels, in the atrium of the Mantuan church of Sant'Andrea, depicting the *Ascension*, *Saints Andrew and Longinus* (dated 1488), the *Deposition* and the *Holy Family*. These were discovered, in a very bad state, in 1915; they had been covered by neoclassical frescoes which imitated their composition. Restored by 1961, the *Ascension* provoked comparison with Mantegna, while Correggio and painters of Mantegna's circle were associated with the other 'tondi'. These attributions were soon rejected or, in the case of Mantegna, limited to the 'sinopia' (or underdrawing) of the *Ascension* alone.

On 31 January 1489 Mantegna wrote from Rome to Francesco Gonzaga reminding him to take care of those

76. Pietà
83 x 51 cm
Copenhagen, Statens Museum

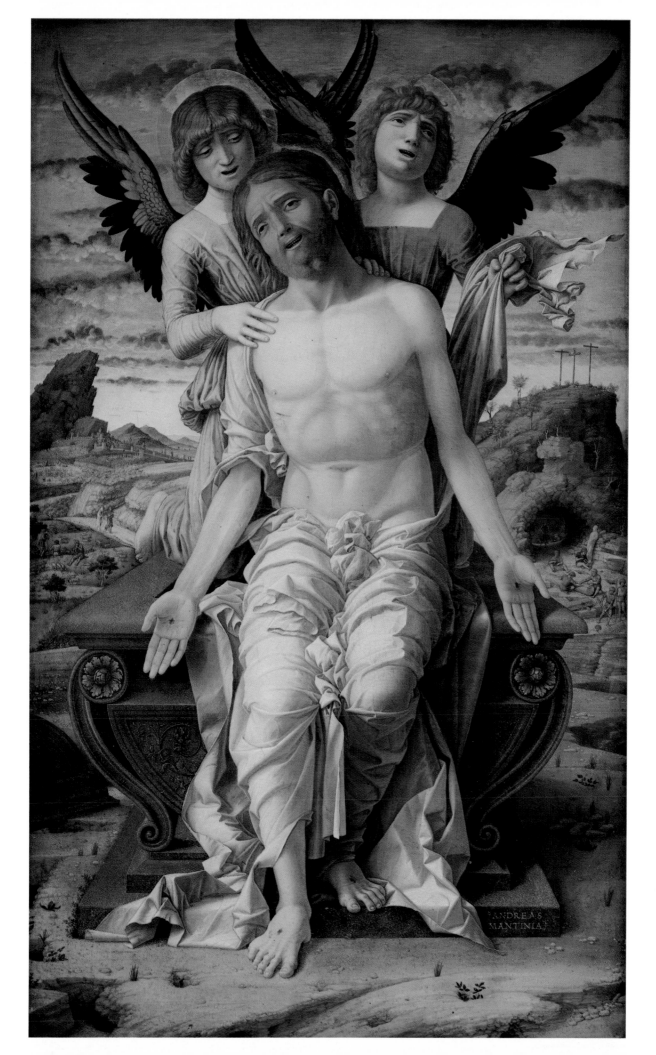

parts of the *Triumph of Caesar* which were already completed. In another letter to the Marchese, dated 15 June, the artist speaks of his work in progress, the decoration of a chapel in the Vatican, for which he is receiving money for the materials alone. In the same letter he amuses His Excellency with news of the papal court, recorded with a devilish glee totally unexpected in an artist who, from his earliest modern biographers, has always been presented as someone grimly immersed in an aura of stern classicism.

It is known that the chapel was demolished in the eighteenth century to make room for the papal archaeological museums. Old descriptions of it, which all agree on its small scale, mention "pleasing" views of towns and villages, "simulated marbles", and "a coffered effect ... interwoven in the manner of latticework" in the "little cupola", while the ceiling of an adjacent "small sacristy" displays "fine foreshortened geometric figures — circles, squares and octagons — simulating coffering", "garlands of fruit", "grisailles on gold backgrounds", "heads of cherubs scattered here and there", allegories of "heroic virtues" and "putti holding up an oval" bearing the dedication and the date 1490. All this provided the framework for lively episodes from the life of John the Baptist and other stories (the *Nativity*, *Epiphany* etc), single figures of saints and evangelists and a portrait of the patron, Pope Innocent VIII. In short, the chapel incorporated much of the decorative repertoire developed in the *Camera degli Sposi* but adapted here to a sacred theme and painted with that same meticulous care and illusionary brilliance so typical of Mantegna and which led Vasari to write that the walls of the chapel "appear to have been illuminated rather than painted".

Vasari assigns to the Rome period the *Madonna of the Quarry* (Florence). This has been seen as an allegory of the Redemption because the landscape to the right of the Christ Child is immersed in shadow with stonemasons working on those symbols of the Passion of Christ — the column and the sarcophagus. The other side of the painting is filled with Christian symbolism: the fields golden with grain, the shepherds leading their flocks, and the hill-top city shimmering in the sun. Mantegna almost obsessively heightens the hardness of the rocks and slabs of stone, accurately rendering their lapidary quality in extraordinary detail. But, in contrast to this severity, the bonfire-shape of the outcrop of shaley stone is struck by the reflected rays of the setting sun and the clear green light of the sky is diffused over the whole scene, eroding the outlines of the distant hill and the gigantic overhanging cliff.

This dichotomy of style, evident in the *Madonna of the Quarry*, is a consequence of that uneasy balance, never quite resolved, between differing stylistic trends: the northern and the Italian, the Gothic and the Renaissance which vie for position in Mantegna's work and which are only tenuously dependent on the varied subject matter he is dealing with. Of course, need it be said that Mantegna manages to resolve these difficulties in an almost flawless stylistic cohesion. However, this duality of artistic language does tend to lead each scholar into his own interpretation of Mantegna's development and it makes the verification of a chronology for undated works difficult.

In expectation that these difficulties will one day be resolved, it is worth noting some works of around 1490 which belong to the period either just before or just after Mantegna's two years in Rome. These years are, for a number of reasons, somewhat puzzling, especially with regard to Mantegna's rapport with antiquity.

This group of paintings include some executed in thin glazes of tempera that reveal the texture of the canvas beneath. The earliest of these could be the Poldi Pezzoli *Madonna* (Milan) in which the Mother and Child are locked together in a compact, painterly volume. The *Butler Madonna* (New York, Metropolitan Museum) is similar; it is probably a copy of a lost original. Here the Christ Child, who rests his feet on the parapet, giving a sense of space and forging a link with the faithful, brings to mind the *Presentation at the Temple* (Berlin). In another *Madonna*, in Bergamo, the Christ Child is once more the protagonist in Mantegna's spatial game; his stiffly extended left leg juts at right angles (like a compass) to the other one. In two other variants (in Berlin and the Philbrook Centre, Tulsa) the Christ Child is once more a full length figure but now actually seated on the ledge — a marvellous invention which makes one long to know the lost original.

Given such a convergence and development of different ideas it is no wonder that the study of Mantegna's work is beset with problems of chronology. One should also add the complications both of Mantegna's slow working methods, for which his patrons often reproached him, and the bad condition of the works. The Poldi Pezzoli canvas, for example, is covered with a thick layer of yellowish varnish which contributes, in part, to that painterliness for which it is admired. There is equal uncertainty about the *Christ Child Blessing* (Washington) for which many conflicting dates have been suggested.

The great painting of the *Pietà* in Copenhagen is thought by most critics to belong to the Roman period chiefly because of similarities with the *Madonna of the Quarry*. Apart from the recurrence of the stonemasons, the sunset also reappears but here it is painted in sharp acidic tones of yellow, green and pale blues which provide a charged chromatic counterpoint to the anguish

77. Madonna of the Quarry
29 x 21.5 cm
Florence, Uffizi

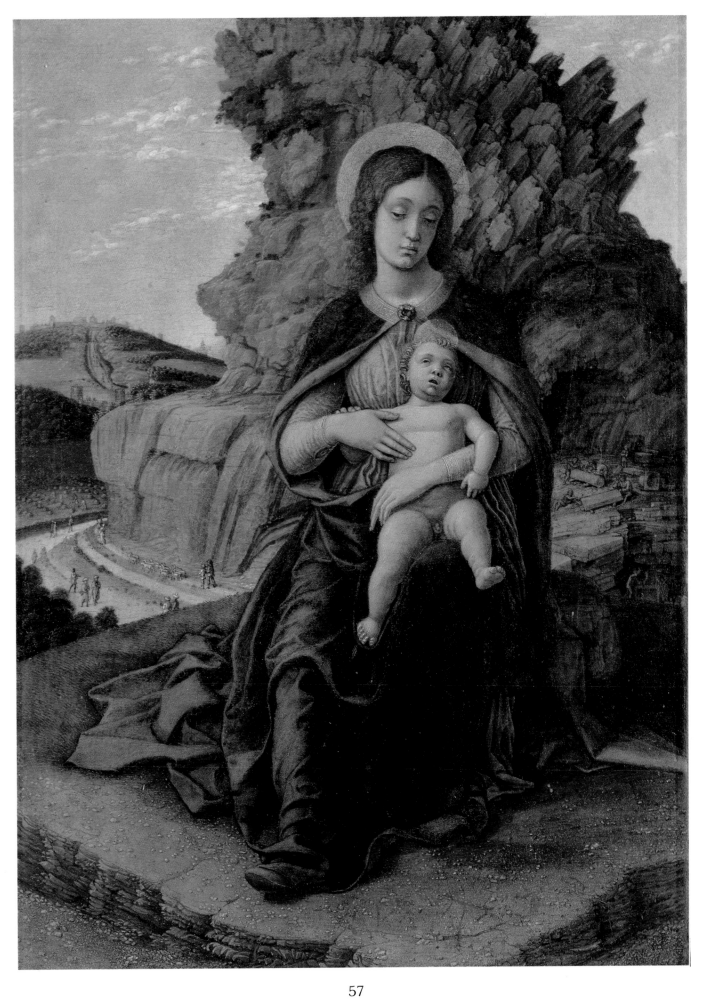

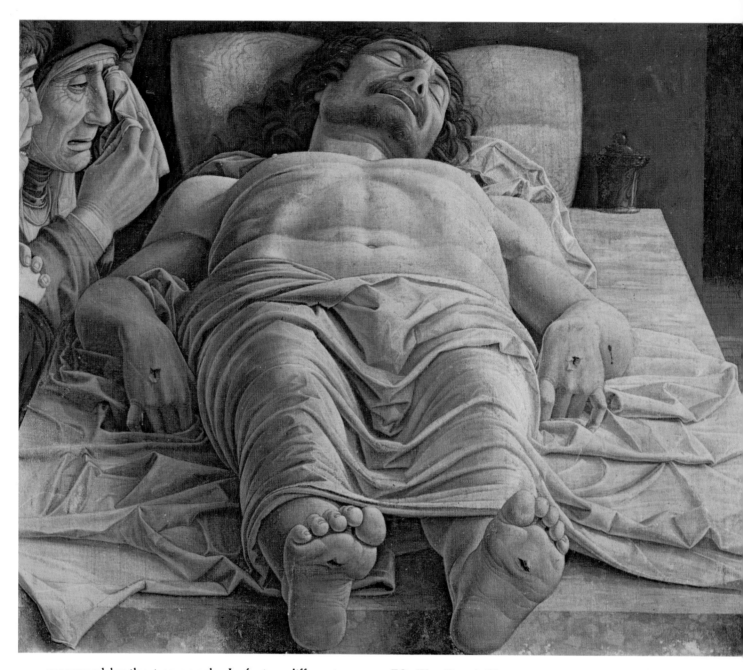

78. *The Dead Christ*
66 x 81 cm
Milan, Brera Gallery

expressed by the two angels. In fact, a different emotional tone is discernable in the *Pietà*; the handling of the narrative, which in earlier works had been understated and contained, now breaks out into "an affirmation of energy, in which grief is expressed with harsh shrieks and through a continual contraction of outlines" (R. Cipriani). Of course, these tragic howls are depicted solely because the subject matter allowed for it but it is still worth pointing out that, having abandoned the immobility conveyed by the *Camera degli Sposi* figures, Mantegna here expresses a looser, more spontaneous fluency hitherto unknown in his work.

Should we connect this 'liberation' with the Roman period? Judging from the *Triumph of Caesar* the artist's third great project, the answer is no. This is because the first paintings in this series, which date from c.1485, reveal that the turning-point came before Mantegna's time in Rome.

The Triumph of Caesar

The *Triumph of Caesar* consists of nine large canvases in tempera; these are listed below with information on the condition of each painting: 1. *Ensign Bearers*, in bad condition (the moor's head is a modern restoration). — 2. *The triumphal chariot with a statue and bearers of war machines, idols, shields and trophies*; in fairly good condition. — 3. *Bearers of trophies and precious silverware*; partially repainted in the eighteenth century. — 4. *Bearers of goldsmith work and precious vases; sacrificial bulls and trumpeters*; in good condition, except for the sky. — 5. *Trumpeters, bulls and elephants*; some old retouching. — 6. *Bearers of goldsmith work, trophies and coronets*; in the same condition as 4. — 7. *Captives, buffoons and an ensign bearer*; completely repainted in the eighteenth century. — 8. *Musicians and ensign bearers*; almost the same as above. — 9. *Julius Caesar on his triumphal chariot*; in bad condition.

Despite the numerous Latin inscriptions, for the most part legible, we do not know which of the various triumphs of Caesar is celebrated here; perhaps none in particular. Many literary sources have been proposed, including the historical works of Livy, Appian of Alexandria, Flavius Josephus, Suetonius and Plutarch, which were all available in Venice from 1450 to 1475. Of modern sources we have the lost book by G. Marcanova, friend of Mantegna, the *Roma triumphans* of Flavio Biondo, and the *De re militari* of Valturio which all appeared at around the same time. The fact that Mantegna's iconographic sources seem to be limited to those classical works then available in Padua, Venice, Verona and Mantua serves to underline the minimal impact which the Roman period had on the classical literacy of the artist.

Since 1690 the *Triumph* has been restored many times, the most damaging restoration occurred in the eighteenth century; this was not remedied by that of R. Fry in 1910. In 1931-34 K. North arrested the colour loss but worsened the lighting, already impaired by the stripping away of the original varnishes. Following the most recent work on the canvases the situation is that indicated above.

Eight or more letters make up the historical docu-mentation of the cycle; they are not conclusive in dating it to the decade 1485-95; work could have continued over a few more years and possibly comprised other pieces such as simulated pilasters. So we do not know how many canvases were finally installed in the San Sebastiano palace which was almost complete in 1506 and which is now unrecognizable because of its dilapidated state. In 1626 seven of Mantegna's canvases were in the Ducal Palace along with two by L. Costa; three years later the ruling Gonzaga sold nine canvases to King Charles I of England. They were all declared to be "by the hand of Mantegna" and, despite all the damage and repainting, this is confirmed by the quality of these paintings which have been at Hampton Court Palace since 1649.

The study of the series is further complicated by the fact that since April 1481 the artist had been working at the Marchese's residence at Marmirolo (it, too, demolished). Here, under his supervision, various painters worked between 1491-94, on frescoing the 'Room of the Horses', the 'Room of the Map of the World', the 'Room of Cities' and the 'Greek Room'. This last room was painted with views of Constantinople and other Levantine places, showing interiors of mosques, bath-houses and other typical Turkish subjects — further proof of Mantegna's endless invention. This same fertile imagination had produced, still for Marmirolo, a series of *Triumphs*, thought to be based on Petrarch but more probably connected with Alexander the Great. These were transferred to Mantua in 1506 to serve as the scenery for a theatrical performance. The relevant documents have led some historians to identify these as the *Triumph of Caesar* which has confused the issue further.

At Hampton Court the nine canvases are hung at a height determined by the 'sotto-in-su' (foreshortened from below) perspective. Nevertheless, quite independently of the loss of the fictive pilasters (which must have been important), another relevant factor seems to be missing. For example, in the sixth canvas the figures are turned towards the inside of the 'pictorial cube', in the second the opposite is the case. In fact here we even witness a change in direction of the procession with the

59

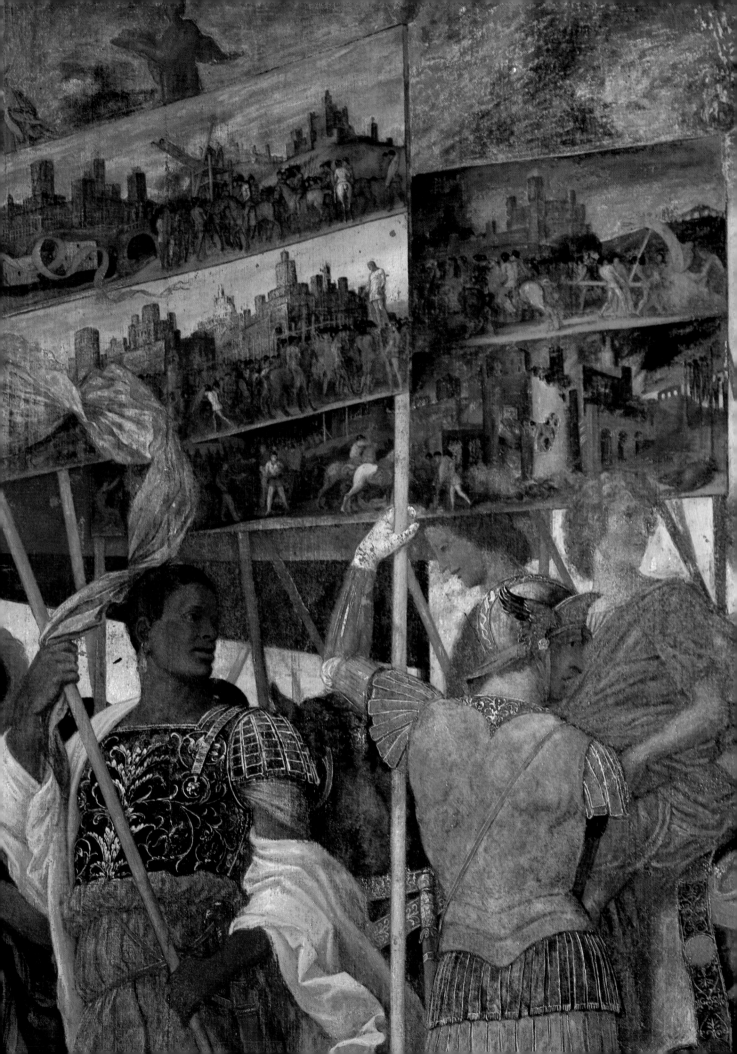

The Triumph of Caesar
c. 267 x 278 cm each
Hampton Court, England

79, 80. Ensign bearers and
detail (1)

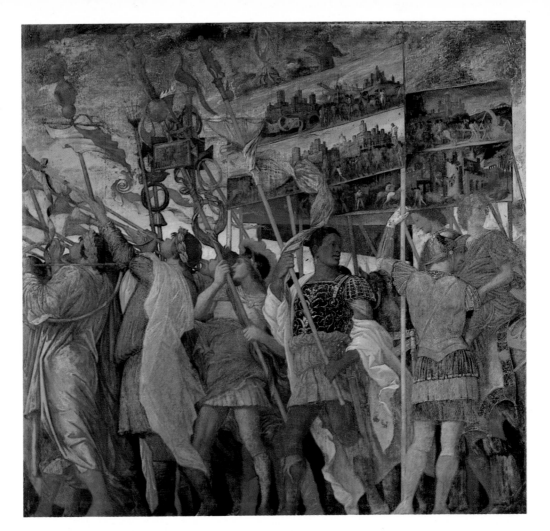

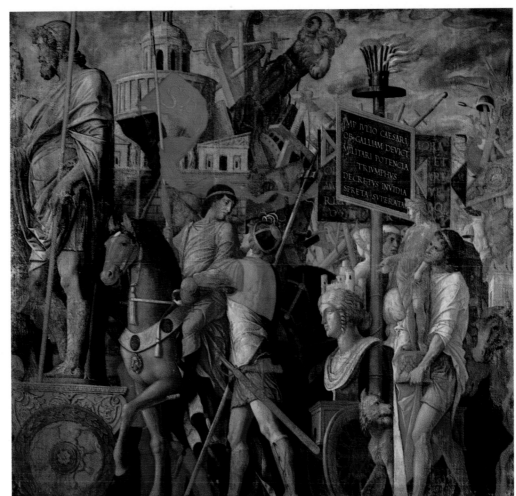

81. The triumphal chariot
with a statue and bearers
of war machines, idols,
shields and trophies (2)

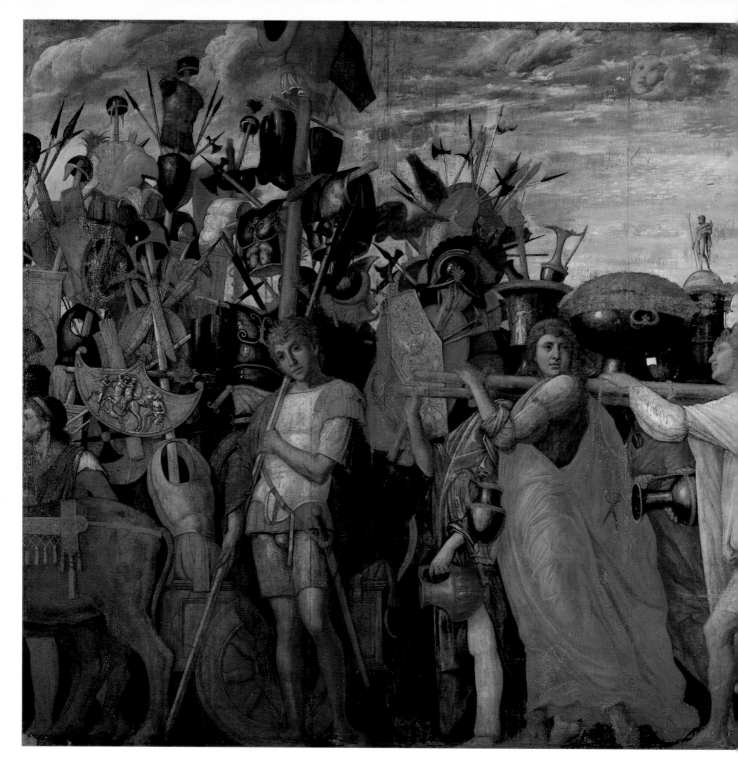

horse coming diagonally out from the background and the chariot on the left heading back into it. In fact, the flow of the procession varies from canvas to canvas and, while the vanishing point of the perspective might be at the centre of one composition, in another it will be on the right or on the left. In some the vanishing point is so low that the feet of the foreground figures disappear.

In short, the perspective changes constantly and forces the spectator to make corresponding adjustments. Each composition has a single viewpoint, but the sequence of all nine together creates a multiple perspective which leads one to suppose that the series was worked out with the surmise that the audience would be moving about. We can no longer fully understand or appreciate the extraordinary impact this must have had.

Mantegna's assiduous adherence to truth remains unchanged as does his ceaseless quest to attain a more atmospheric pictorial cohesion. This means that his style is firmer than ever in defining unexpected details and bold foreshortenings, leading to a rigorously unified harmony. This heroic exaltation of a vanished — or imagined — world and the clamour of the throngs of people settles, in the end, into a nobility no less dignified than the *Camera degli Sposi* but rendered more animated and believable, more capitivating and immediate.

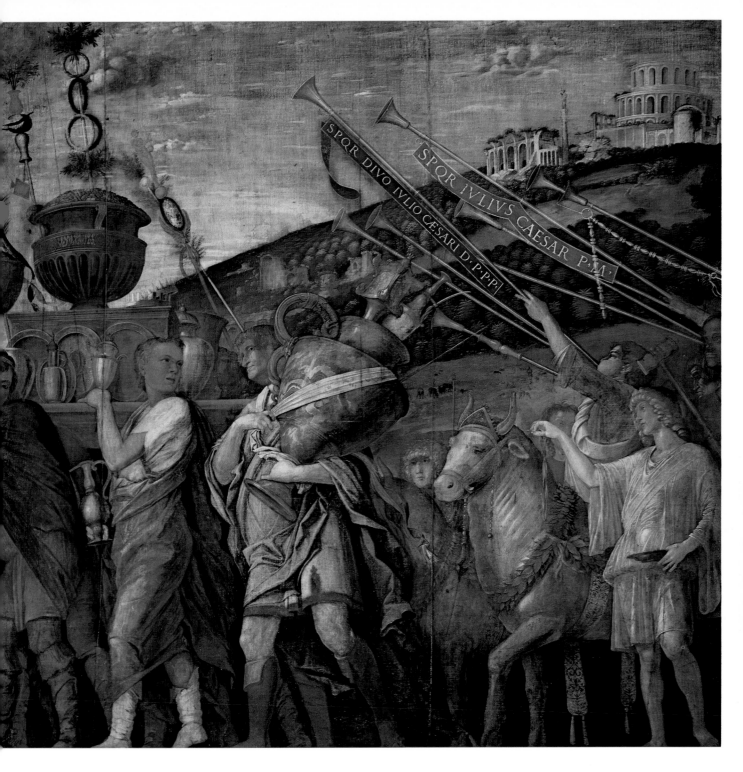

82. Bearers of trophies and precious silverware (3) *83. Bearers of goldsmith work and precious vases (4)*

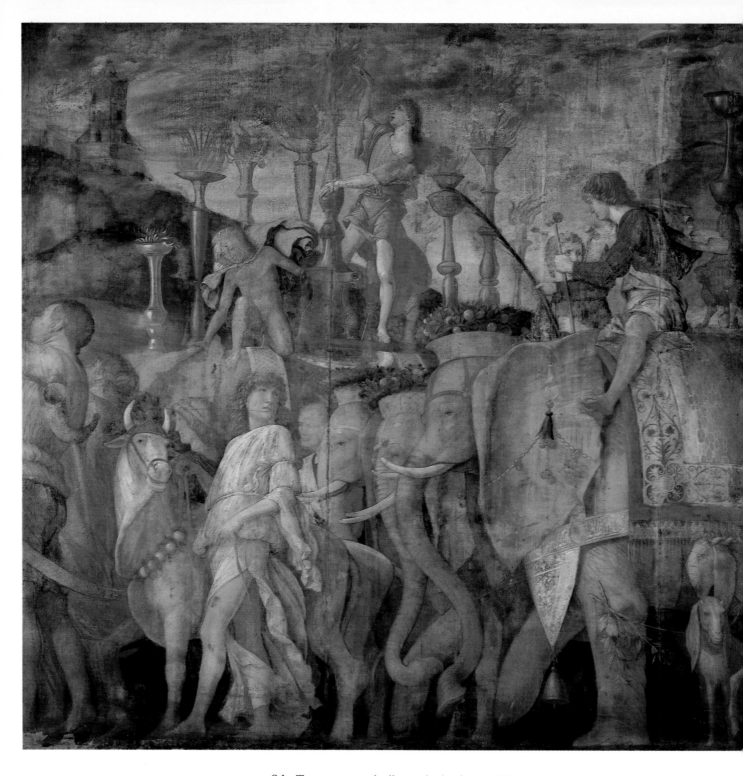

84. Trumpeters, bulls and elephants (5)

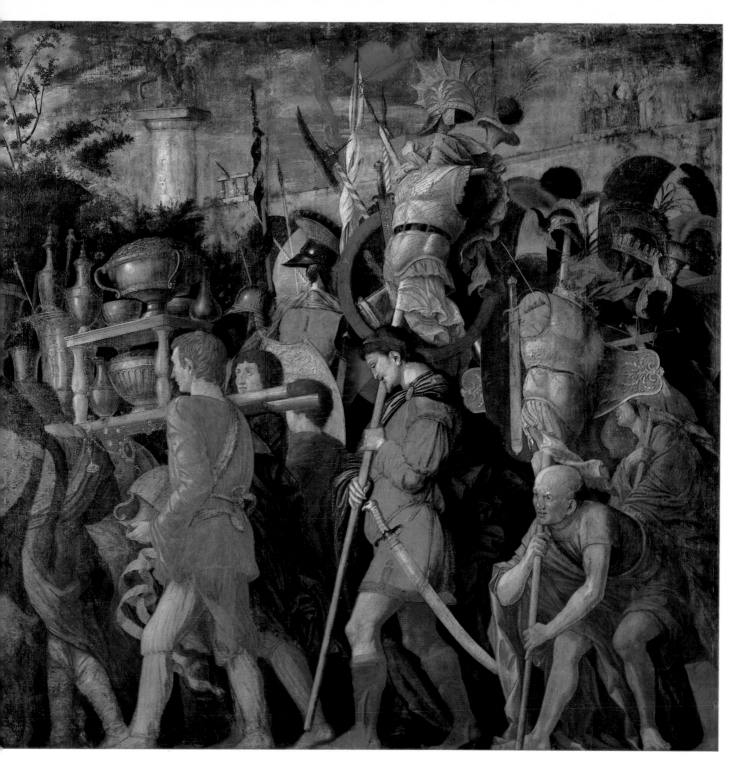

85. Bearers of goldsmith work, trophies and coronets (6)

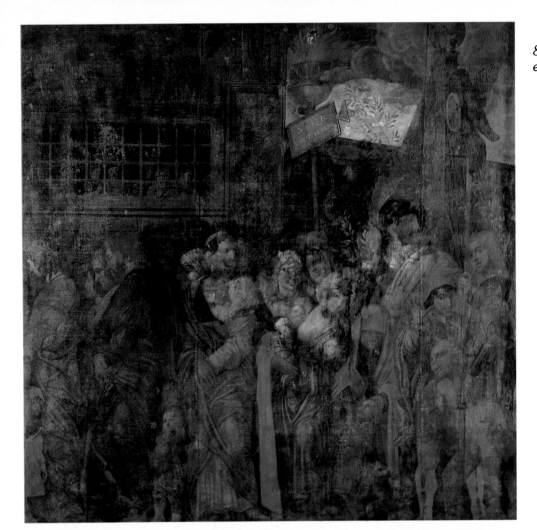

86. Captivies, buffoons and an ensign bearer (7)

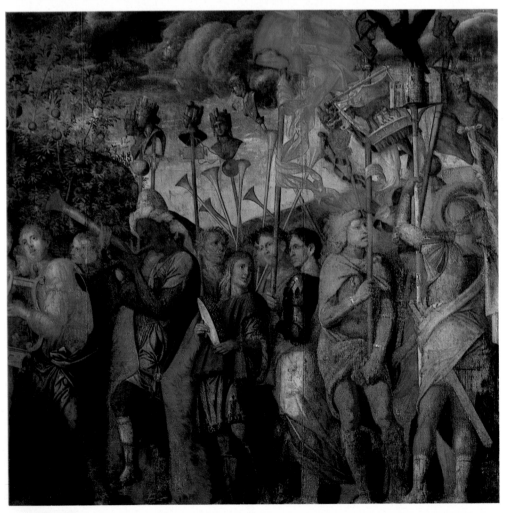

87. Musicians and ensign bearers (8)

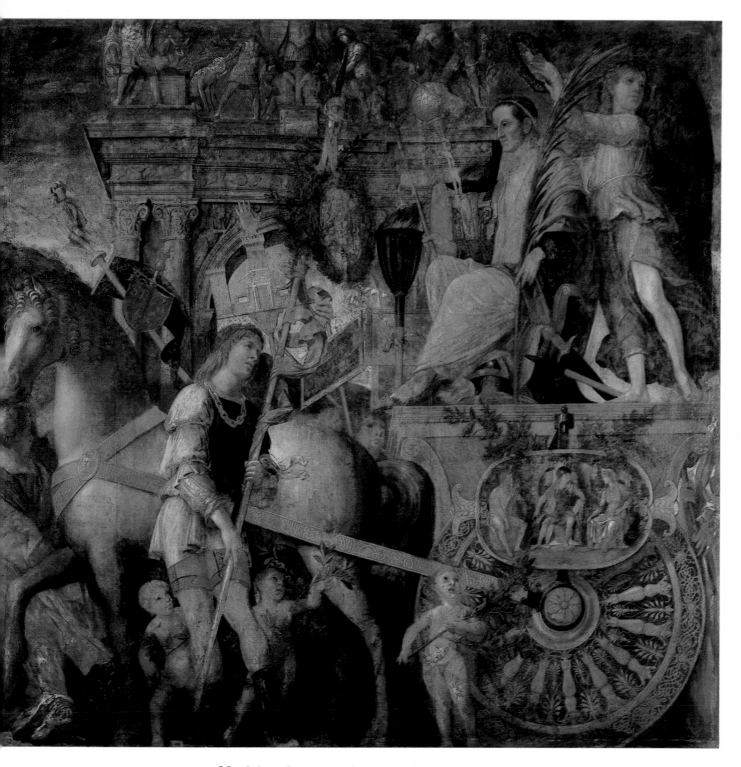

88. Julius Caesar on his triumphal chariot (9)

The Late Works

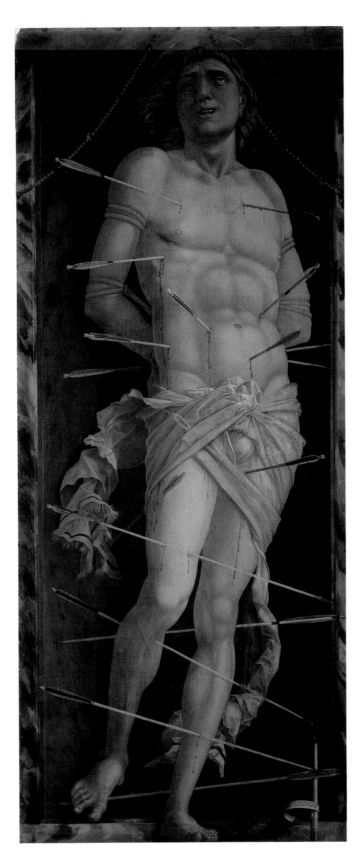

It is not merely for stylistic reasons that the Milan *Dead Christ* has been erroneously placed among the last works of Mantegna; it is often supposed that artists, particularly great ones, are more aware than most of their approaching end and express this presentiment in appropriately sombre subject matter.

The *St Sebastian* in the Ca' d'Oro, Venice, is often given a much later dating for similar reasons and especially because of the funereal bitterness of the scroll entwined around the candle, on the lower right of the painting. Like the Brera canvas, the *St Sebastian* was on the list of works still in Mantegna's studio at his death in 1506 and it seems to have been destined for Cardinal Sigismondo Gonzaga. The general opinion that it dates from shortly before his death is challenged by only a few critics who place it near the *Triumph of Caesar*. Judging from the window-like frame a dating around the beginning of the *Triumph* series, or earlier is not unlikely. The condition of the painting might explain why it was still in the studio after so many years for there is evidence of a total reworking — probably by Mantegna himself. The prudish addition of a loin-cloth, consisting basically of a mass of white paint, totally formless and discordant, must be the work of an assistant, probably Mantegna's son, Francesco, who followed only modestly in his father's footsteps. It does nothing, though, to extinguish that shudder that runs through the body of the martyr before erupting into a cry of pain causing him to burst from the 'window', violated and tormented by the arrows that strike him from all directions.

The sombre *Christ the Redeemer*, at Correggio, possibly a fragment of a larger work and in bad condition, certainly belongs to 1493. Of similar date, or a little later, is the *Holy Family with the Young St John the Baptist and a Saint* at Dresden which, inspiring compassion and devotion through its static serenity, must have been very popular. In fact, we know a number of versions but in even the best of them (Verona, Castelvecchio; Paris, Jacquemart-André; Turin, Galleria Sabauda) the quality is severely compromised as a result of collaborative execution and restoration. The standing Christ Child reappears in two other canvases, one in London (National Gallery) and the other in Paris (Petit-Palais) where the Virgin can be seen sewing. In the London version only the parapet becomes a well which, somewhat incongruously, encloses the figure of the Virgin; perhaps it should be read as the mystical well of the 'hortus conclusus' or it could allude to the Immaculate Conception (which did not become dogma until 1854). Neither of these versions with the sewing Madonna seems autograph.

89. St Sebastian
210 x 91 cm
Venice, Ca' d'Oro

90. *Christ the Redeemer*
53 x 43 cm
Correggio, Congregazione di Carità

91. *Holy Family with the Young St John the Baptist
and a Saint*
75.5 x 61.5 cm
Dresden, Gemäldegalerie

92. *Imperator Mundi*
Paris, Petit Palais

So we come to the *Madonna of Victory* (Paris) com-
missioned by Francesco II Gonzaga, who is depicted
kneeling to the left, blessed by the Virgin and accompa-
nied by Saints Michael and Andrew. These are
balanced on the other side by St George and a kneeling
female figure whose identity is uncertain. The painting
was commissioned to celebrate Francesco Gonzaga's
inconclusive military victory over the French at Fornovo
on 6 July 1495. On the first anniversary of the battle the
altarpiece was installed with great ceremony amid
scenes of indescribable jubilation. Early critics have
been less enthusiastic about the work, singling out the
lack of proportion of the composition and the generally
hard quality of the painting. It has been further
diminished by more recent scholars, whose criticism is

69

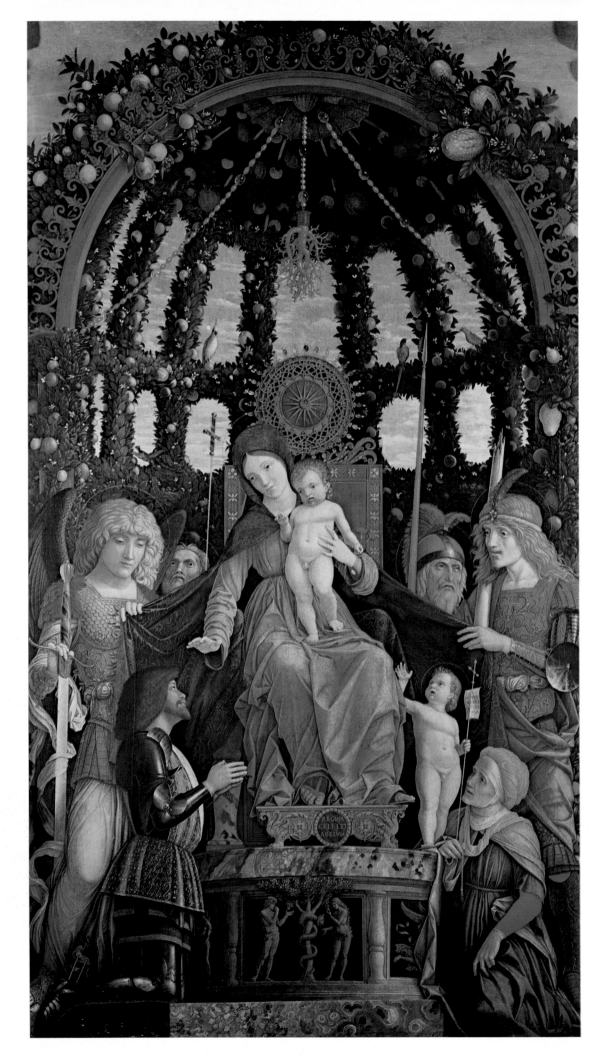

93. *Madonna of Victory*
280 x 160 cm
Paris, Louvre

94. *Trivulzio Madonna*
287 x 214 cm
Milan, Castello Sforzesco

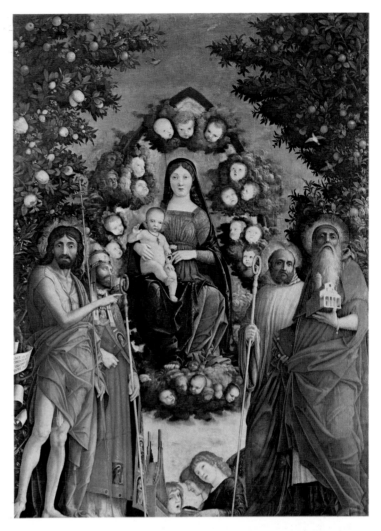

95. *Madonna with Child and Saints*
(after recent restoration)
61.5 x 87.5 cm
Turin, Galleria Sabauda

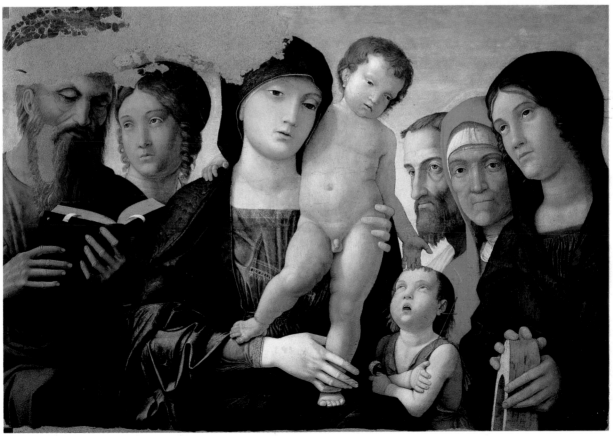

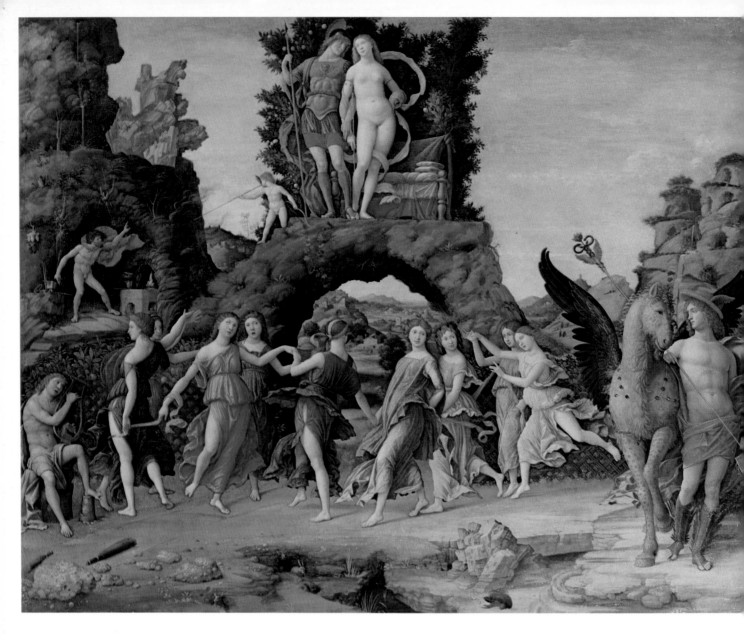

not always justified, and who see in it a self-conscious quest for compositional symmetry and asymmetry for its own sake; an apparent disparity between the iridescent lighting and the showy splendour of the fruit and the little parrots in the pergola, has been criticised along with the inconsistency between the large scale of the picture and the miniaturistic exactitude of the technique.

In fact, we are seeing the work out of context. It was placed in a specially designed chapel where, presumably, the obsessively meticulous style was tempered by the character of the setting (about which we know nothing). This seems all the more likely if Vasari is right in telling us that Mantegna designed the chapel itself — an idea rejected by nineteenth century scholars. Bearing this in mind it is worth noting that there is in this painting an echo of the central part of the San Zeno altarpiece where Mantegna abandoned the 'scenic' perspective to which he had been faithful since the second level of the Ovetari frescoes. This change is evident in the Dresden *Holy Family*, mentioned above, and before that, in the

96, 97. Parnassus and detail
160 x 192 cm
Paris, Louvre

Madonna of the Quarry. In other words, after his daring rejection of Brunelleschi's centralized perspective system in order to follow the 'anticlassical' spatial ideas of Donatello, Mantegna returns to Brunelleschi's conception of space as the ideal measure of the visible world and the identification of art with a higher form of harmony, just when Botticelli and Michelangelo were turning their backs on this idea. This is why in the *Madonna of Victory* the trompe l'oeil is faultless and perfectly judged and there is the same dramatic use of the 'sotto-in-su' viewpoint as in the *Triumph of Caesar*. Once more the atmospheric use of colour has a unifying effect accentuated here by the richness of the tones which focuses attention on the Marchese (who commissioned the work) and who is made even more emphatic through a bold interplay of light and shade. But these

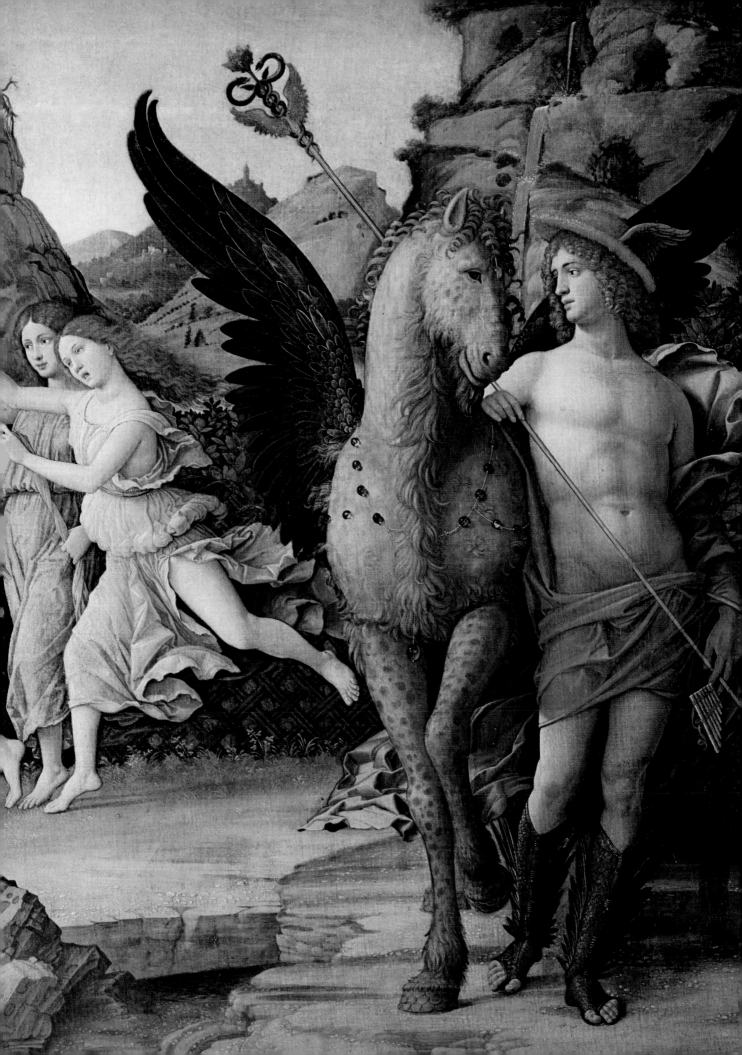

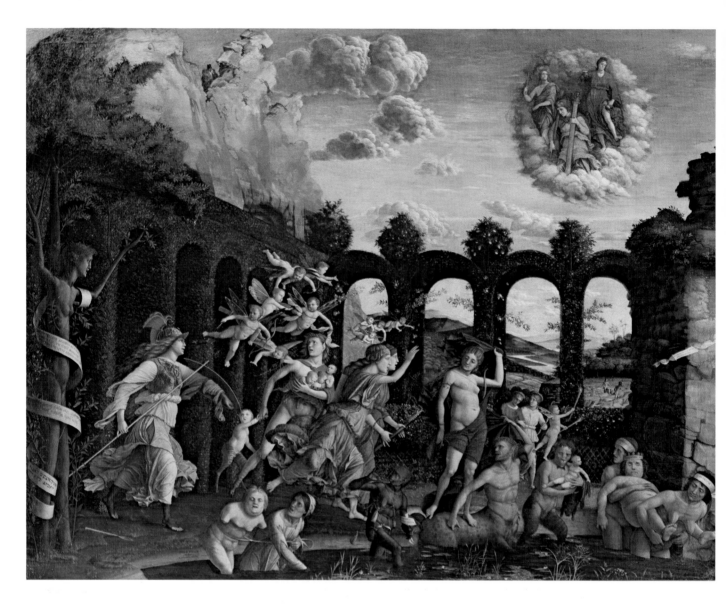

devices are no longer used to faithfully mirror the visible world but instead to create an abstract, intellectualized vision.

The *Trivulzio Madonna* (Milan) is inscribed not only with the year, 1497, but even the day — 15 August. Here we can identify St John the Baptist and, probably, Saints Gregory the Great, Benedict and Jerome. It was painted for the high altar of the Veronese church of Santa Maria in Organo, the model for which is held by the 'Cardinal' St Jerome. A critic known for his balanced opinions, G. Bazin, described it, in 1961, as "curiously unsuccessful" which interrupted that flood of praise directed at the work by the majority of modern scholars who admire it for its exclusion of any reference to real space, an effect achieved through the very low viewpoint. Because of this viewpoint, the strong verticality of the whole composition, aided by the chromatic brilliance of the vegetative 'wings' of the picture, is thought to take on, "the resonance of an immense nave". This interpretation is difficult to follow. Here we are even further away from a Donatellian perspective scheme than we were in the *Victory* altarpiece. Mante-

98, 99. The Triumph of Virtue and detail
160 x 192 cm
Paris, Louvre

gna has adopted a composition of great formal composure: the oval of the Madonna's face — which is quite delicately coloured, hitherto unknown in Mantegna — becomes the centre of a series of waves radiating out from the almond-shaped aureole containing the cherubs, culminating in a repetition of that 'mandorla' shape in that area of sky which is free from foliage and saints. The format is not intended to be believably realistic but is based instead on an 'a priori' concept; and there is only the barest memory of Mantegna's earlier ideas in, for example, the tension created between the 'sotto-in-su' viewpoint of the four saints and the contrasted foreshortening of the angel-musicians. It is not clear whether the rigidly frontal presentation of the central group serves to underline this tension or, as seems more probable, to provide a soothing counterpoint to it.

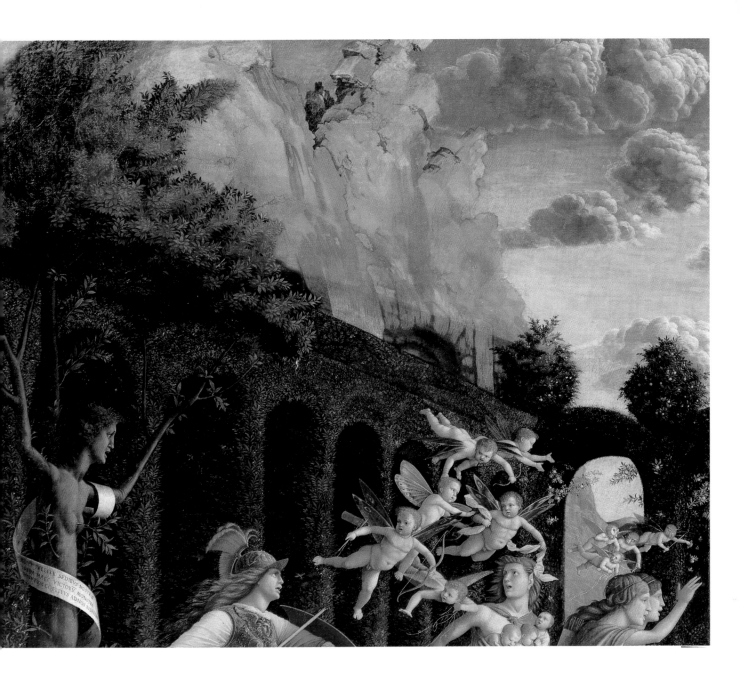

1497 is perhaps also the year that saw the completion of the *Parnassus* destined for the 'Studiolo' of Isabella d'Este in the Castel San Giorgio. The Marchesa's idea of creating for herself a 'thinking chamber', in the humanist tradition, began five years earlier; it was possibly then, in 1492, that Mantegna painted the two simulated bronze reliefs, recorded in 1542 but which are now lost. The *Studiolo* programme must have been more complex and was probably modified over the years. What is clear is that in 1503, Perugino, one of the artists called on to contribute to the *Studiolo*, signed a contract in which every single detail of the subject matter of his painting was carefully laid down. Giovanni Bellini, who was contacted in 1501, abandoned the project having tried, without success, to ensure himself complete artistic liberty.

The *Parnassus* poses a number of iconographical problems. The dancing Muses are easily identifiable,

both on account of their number and the presence of the crumbling mountains in the top left of the picture. There was a tradition that the song of the nine sisters caused volcanic eruptions and other cataclisms which could only be stopped by Pegasus stamping his hoof — and indeed we see, on the right, the winged and bejewelled horse engaged in his providential pawing of the ground. Beside him is Mercury, whose presence is justified by the protection which he (together with Apollo) afforded the adulteress in the love affair between Mars and Venus. The two lovers hold sway over the scene from the top of Parnassus; a bed is beside them. The cuckolded husband, Vulcan, springs out from the entrance of his forge, fulminating against the faithless pair. The grapes hanging behind him possibly symbolize strength and intemperance. Apollo is seated lower down, his lyre in his hands.

There can be no doubt about the moralising intent of

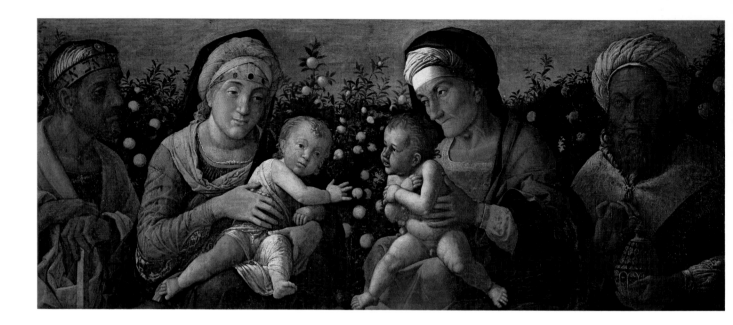

the series. This is clear from the information given in Perugino's contract, mentioned above, and from the themes of the other paintings. It is easy to read into the *Parnassus* the Muses' condemnation of the illicit union of Mars and Venus. However, it does appear that the learned men of the Mantuan court did not disapprove of the affair, if we are to believe that complicated interpretation of the *Parnassus* as an erotic burlesque suggested by Wind in 1949 and sensibly rejected by later scholars. Stylistically the painting anticipates both the colouring typical of Venetian painting in the early sixteenth century and the 'Olympian' harmony achieved by Raphael only after 1510, while at the same time there are echoes of that goddess rising from the sea, painted a good twenty years earlier by Botticelli in the Uffizi *Birth of Venus* (G. Fiocco).

It is clear that in the *Parnassus* Mantegna's style displays traits — already in part discernible in the *Trivulzio Madonna* — which are divergent from his usual manner of painting. There is a greater interest in blending all the elements of the composition, landscape and figures, mountains which are almost too carefully manipulated to echo gestures of a masterly and self-conscious affectation. It is enough to single out, in the *Parnassus*, the Muse who turns to Apollo and uncomfortably arches her body in order to repeat the line of the hillock that serves as the sinful bedchamber.

Apart from making use of Brunelleschian perspective Mantegna is discovering — and in this he was anticipated by Leonardo alone — that supreme harmony that transforms the vision of the world into ideal beauty: he was moving, then, towards the fully developed classical spirit of the Renaissance, which was really the logical extension of Brunelleschi's original vision. In the end, this discovery was detrimental to that honest and reflective quality which is so strong in Mantegna's work up to the *Triumph of Caesar*. Now, the artist's guiding

100. *Holy Familiy with St John the Baptist and his Parents*
40 x 169 cm
Mantua, Sant'Andrea (Mantegna's funerary chapel)

101. *School of Mantegna*
Occasio et Poenitentia
168 x 146 cm
Mantua, Ducal Palace

authority seems to be that of coercing compositional elements into a carefully calculated structure and, inevitably, these elements, burdened by the priority of connecting with each other compositionally, become empty metaphors. It was too high a price to pay for being in the forefront of new artistic ideas.

All this is best, or should we say worst, expressed in the *Triumph of Virtue*, completed in 1502 as a companion piece to the *Parnassus*. Minerva, goddess of Virtue, expels the shameless Venus, along with the Vices, from the Garden of Virtue, as we learn from the scroll entwined around the Mother of Virtue (to the left) who is imprisoned in an olive tree. From the sky the Cardinal Virtues approvingly observe the scene. It is not clear, though, why the rocks in the background crumble into monstrous shapes or why the clouds take on human features. The literary sources have been identified as the *Dream of Poliphylus* (Venice, 1499) and Boccaccio's *De genealogia deorum gentilium*. Beneath a sky that (hot-air balloon cloud apart) is the most impressive in European art before those of Altdorfer, and surrounded by enjoyable fantasies (the goddess-cum-olive tree is worthy of Bosch at his best) Minerva hurtles towards a tangle of Vices whose hasty retreat has been held up by Venus intent on her toilette in preparation for her own getaway. And so, devoid of any other emotions, the narrative concludes with a bold piece of fore-

shortening whose sole purpose is to fit into the triangle which the artist has so obsessively imposed.

The third canvas painted for the *Studiolo* is the *Myth of the God Comus*, started by Mantegna but completed after his death by Lorenzo Costa who repainted the parts already done, thus making it impossible to distinguish Mantegna's hand.

The *Adoration of the Magi* at Malibu (Getty Museum), with its measured group of reverential heads, belongs to Mantegna's final period, as does the *Ecce Homo* in Paris (Jacquemart-André) which conveys a hard-hitting, not to say cruel, sense of tragedy. The decoration of Mantegna's own funerary chapel in Sant'Andrea in Mantua also dates from his last years. Here we find the *Holy Family with St John the Baptist and his Parents* and the *Baptism of Christ*; appropriate subject matter for a chapel dedicated to the Baptist. While the first painting seems to be, at least in part, autograph, the *Baptism* is difficult to analyse chiefly because of the heavy laying-on of the paint, due to assistants, possibly even Correggio, who was then not more than fifteen. A more likely candidate is Mantegna's son, Francesco, who in 1516 certainly carried out the fresco decoration of the chapel, probably using his father's drawings.

The chapel also contains the bronze bust of the artist, mentioned earlier. The sculpture has had other attributions but there is no reason why it should not be a self-portrait, as Scardeone asserted in 1560. Made at any time between 1480 and 1490 it presents us with a very realistic and expressive face which also displays a cer-

tain amount of self-celebratory idealization. This seems to fit perfectly with what we know of Mantegna's character, especially in his later years; a man highly (even aggressively) aware of his own talents as is revealed in various letters and in the accounts of disputes involving members of the Gonzaga family themselves.

In connection with these conflicts it is worth returning to the *Studiolo* project, consideration of which is incomplete without acknowledging the conditions under which Mantegna had to produce his paintings and which go some way to explaining his behaviour. It is not difficult to detect in the two surviving *Studiolo* paintings evidence of a three-fold collaboration in the genesis of the works. We have the patron, the Marchesa, whose relations with Mantegna had been stormy for at least ten years; the court scholar (who may have been Paride Ceresara) whose written programmes covered every possible allegorical detail; and Mantegna himself, shackled to the wishes of the other two, which he struggled to carry out using solutions which were increasingly laboured and sterile. It is clear that from about 1490 Mantegna was experiencing a kind of 'crisis of classicism', arising from a desire to find new forms of expression and — although the final result was an entirely personal style — it was perhaps stimulated by Leonardo's presence at the Milanese court (which had strong links with Mantua through the Gonzaga-Sforza connection).

This change of direction is also evident in other works, contemporary with the *Studiolo* pictures, in which Mantegna's works through this new style more

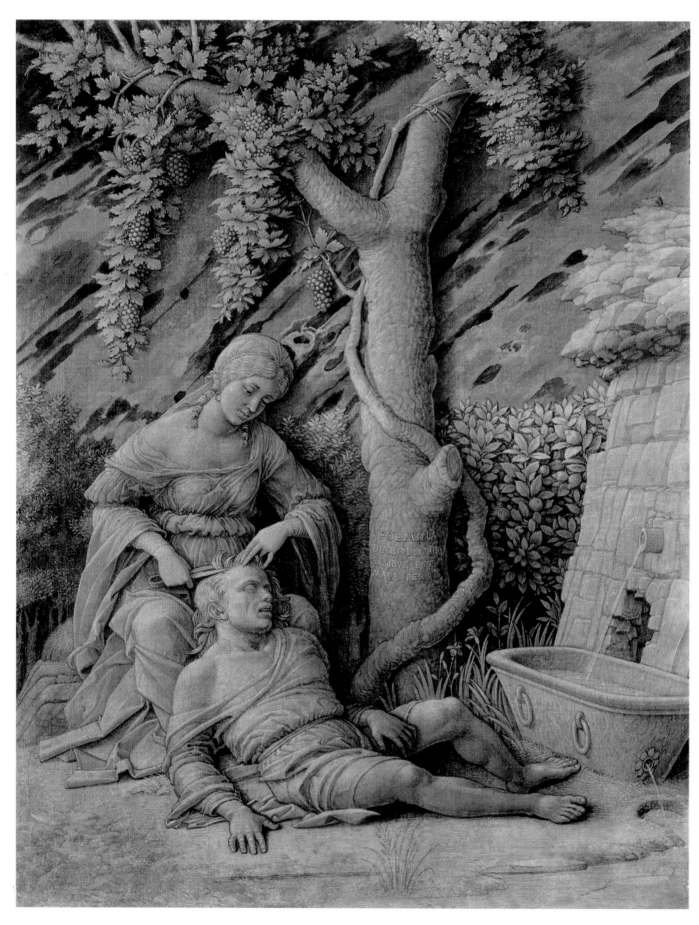

102. Samson and Delilah
47 x 37 cm
London, National Gallery

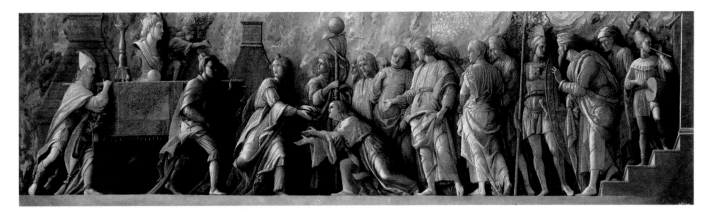

fully. These are various monochrome paintings, all simulating marble relief, sometimes backed by fictive, coloured semi-precious stone inlays, clearly drawn from Mantegna's immense geological knowledge.

This new *genre*, if we could call it that, represented by these works, developed from that rich repertoire of grisaille painting in his mural decoration (it is enough to think of the vault of the *Camera degli Sposi*) which the inexhaustible creative talent of Mantegna had honed to an extraordinary degree of excellence and which is now applied to easel paintings — canvases and panels. It is difficult to establish a chronology for these works. The *Samson and Delilah* in London, is certainly the most polished of the group, an outstandingly fine painting, entirely by Mantegna's hand. The intervention of assistants in this *genre* is marked by a certain heaviness and disjointedness which is just discernible in the Cincinnati *Prophet and Sibyl* (Art Museum) and in the Dublin *Judith* (National Gallery) but is much more accentuated in another *Judith* and its companion-piece of *Dido* in Montreal (Museum of Fine Art); in fact some critics reject any connection here with Mantegna. Other works in Paris, Vienna and, specifically, the *Mucius Scaevola* in Munich, are thought to be workshop, but executed under the supervision of the master. This is not the case, though, with the *Occasio* in Mantua (Ducal Palace).

Mantegna's hand is once more supremely evident in a series in London, comprising the *Tucia*, the *Sophoniba* and the *Introduction of the Cult of Cybele to Rome*. The three works, probably commissioned in 1505 by the Venetian Francesco Cornaro, were not finished by the following January. Mantegna was not able to complete the largest of the three before his death on 13 September 1506; in fact there is extensive painting by other hands.

And so Mantegna's final artistic statement is to be found in the group of Cornaro paintings: it is a compelling and celebratory classicism, in no way drily erudite or cerebral. Here he has achieved that perfect equilibrium where every mutable feature in the composition is fixed, abstracted and imbued with great significance. And this same equilibrium is shot through with a ner-

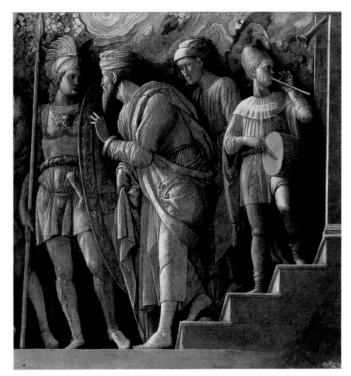

103, 104. Introduction of the Cult of Cybele to Rome and detail
73.5 x 268 cm
London, National Gallery

105, 106. Sophoniba and Tucia
72.5 x 23 cm each
London, National Gallery

vous tension, far removed from the rhetoric of these "sacred marbles"; it is this which restores life to these conventional forms. And it is this same tension which is then evident in the work of Botticelli but which the Florentine painter expresses through a kind of Gothicising abstraction, quite alien to the late style of Mantegna. This nervous tension is still latent in the work of Michelangelo, and hinted at by Raphael and it will reappear to inspire the early Mannerist painters.

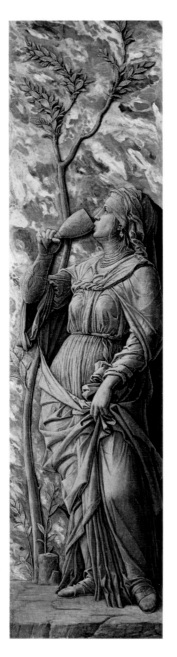

Select Bibliography

P. KRISTELLER, *Andrea Mantegna*, London-New York 1901.

G. FIOCCO, *L'Arte di Andrea Mantegna*, Bologna 1927 (in fact 1926), Milan 1937, Venice 1959.

R. LONGHI, *Lettera Pittorica (. . .) a Giuseppe Fiocco*, in "Vita artistica" I, 1926.

E. TIETZE-CONRAT, *Mantegna*, London and Florence 1955

R. Cipriani, *Tutta la Pittura di Andrea Mantegna*, Milan 1956.

L. COLETTI and E. CAMESASCA, *La Camera degli Sposi*, Milan 1959.

G. PACCAGNINI and A. MEZZETTI, *Andrea Mantegna* (catalogue of the Mantua exibition), Venice 1961.

E. CAMESASCA, *Andrea Mantegna* Milan 1964 (reprinted without the author's knowledge, Novara 1975).

A.M. ROMANINI, *L'itinerario pittorico del Mantegna* (1965) Milan 1966.

L. GROSSATO (ed.), *Da Giotto a Mantegna* (exhibition catalogue), Padua 1974.

S. BÉGUIN, *Le Studiolo d'Isabelle d'Este* (exhibition catalogue), Paris 1975.

A. MARTINDALE, *The 'Triumphs of Caesar'*, London 1979.

E. CAMESASCA, *Mantegna*, Florence 1981.

R. SIGNORINI, *Opus hoc tenue — La Camera dipinta di Andrea Mantegna*, Mantua 1985.

R. LIGHTBOWN, *Mantegna*, Oxford 1986; Italian ed. (very inaccurate) Milan 1986.

C. HOPE, *The 'Triumph of Caesar'*, in "Renaissance Studies in honor of Craig Hugh Smyth", Florence 1986.

E. CAMESASCA and M. CORDARO, *La Camera degli Sposi*, in "Critica d'Arte" 1987.

S. BANDERA BISTOLETTI (ed.), *Il Polittico di S. Luca (. . .)*, Florence 1989.

K. CHRISTIANSEN, in *Le Muse e il principe* (catalogue of exhibition in Milan), Modena 1991.

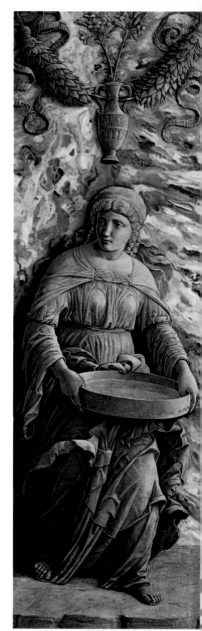

Contents